LURE OF THE WEST

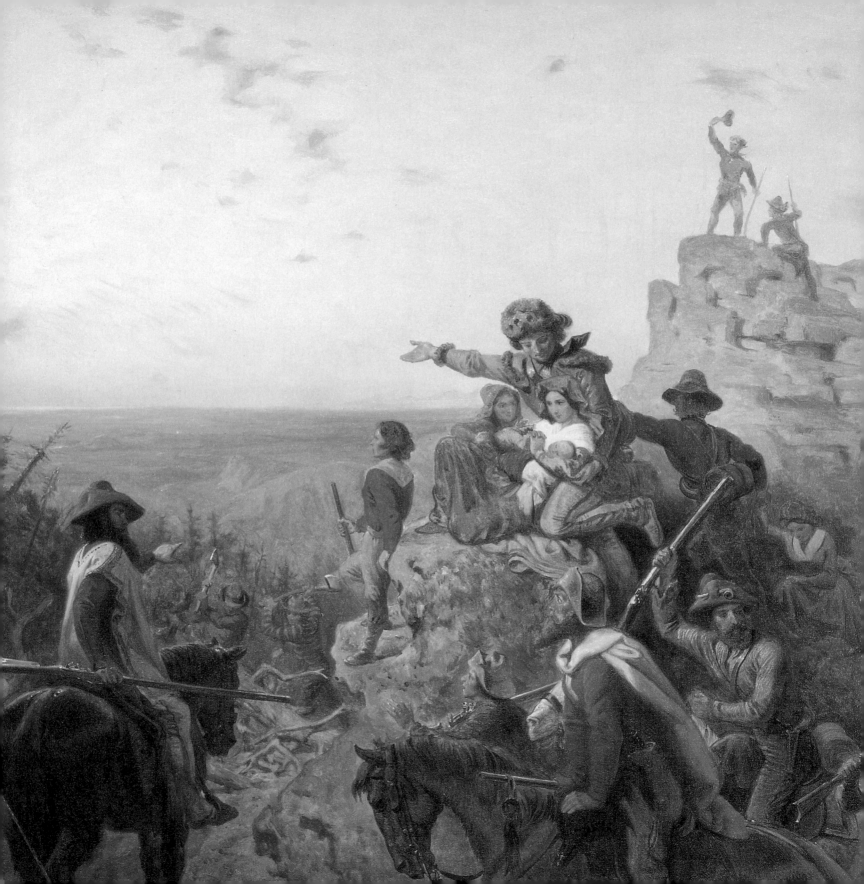

LURE OF THE WEST

Treasures from the
Smithsonian American Art Museum

Amy Pastan

Watson-Guptill Publications/New York

Smithsonian American Art Museum

Lure of the West: Treasures from the
Smithsonian American Art Museum

by Amy Pastan

Chief, Publications: Theresa Slowik
Designers: Steve Bell, Robert Killian
Editor: Timothy Wardell
Editorial Assistant: Tami Levin

Library of Congress Cataloging-in-Publication Data

National Museum of American Art (U.S.)
 Lure of the West : treasures from the Smithsonian
American Art Museum/ Amy Pastan.
 p. cm.
Includes index.
 ISBN 0-8230-0191-1
 1. Art, American—West (U.S.)—Exhibitions. 2.
Art, Modern—19th century—West (U.S.)—Exhi-
bitions. 3. Art, Modern—20th century—West
(U.S.)—Exhibitions. 4. West (U.S.)—In art—Ex-
hibitions. 5. Art—Washington (D.C.)—Exhibi-
tions. 6. National Museum of American Art
(U.S.)—Exhibitions. I. Pastan, Amy. II. Title.
 N6525 .N38 2000
 704.9'49978'007473—dc21
 00-008380

Printed and bound in Italy

First printing, 2000
1 2 3 4 5 6 7 8 9 / 07 06 05 04 03 02 01 00

Cover: Thomas Moran, *Cliffs of the Upper Colorado
River, Wyoming Territory* (detail), 1882, oil.
Smithsonian American Art Museum, Bequest of
Henry Ward Ranger through the National Academy
of Design (see page 76).

Frontispiece: Emanuel Gottlieb Leutze, *Westward the
Course of Empire Takes Its Way* (detail), 1861, oil.
Smithsonian American Art Museum, Bequest of
Sara Carr Upton (see page 70).

Lure of the West is one of eight exhibitions in *Treasures to Go,* from the Smithsonian American Art Museum, touring the nation through 2002. The Principal Financial Group® is a proud partner in presenting these treasures to the American people.

Foreword

Museums satisfy a yearning felt by many people to enjoy the pleasure provided by great art. For Americans, the paintings and sculptures of our nation's artists hold additional appeal, for they tell us about our country and ourselves. Art can be a window to nature, history, philosophy, and imagination.

The collections of the Smithsonian American Art Museum, more than one hundred seventy years in the making, grew along with the country itself. The story of our country is encoded in the marvelous artworks we hold in trust for the American people.

Each year more than half a million people come to our home in the historic Old Patent Office Building in Washington, D.C., to see great masterpieces. I learned with mixed feelings that this neoclassical landmark was slated for renovations. Cheered at the thought of restoring our magnificent showcase, I felt quite a different emotion on realizing that this would require the museum to close for three years.

Our talented curators quickly saw a silver lining in the chance to share our greatest, rarely loaned treasures with museums nationwide. I wish to thank the dedicated staff who have worked so hard to make this dream possible. It is no small feat to schedule eight simultaneous exhibitions and manage safe travel for more than five hundred precious artworks for more than three years, as in this *Treasures to Go* tour. We are indebted to the dozens of museums around the nation, too many to name in this space, that are hosting the traveling exhibitions.

The Principal Financial Group® is immeasurably enhancing our endeavor through its support of a host of initiatives to increase national awareness of the *Treasures to Go* tour so more Americans than ever can enjoy their heritage.

Lure of the West begins soon after the Louisiana Purchase, which changed Americans' idea of the West dramatically. As they ventured beyond the Appalachian Mountains, explorers sent back dispatches about their discoveries and helped write a new chapter in America's story. Stirred by these words and by images of the pristine wilderness, many settlers turned westward. Stunning mountain landscapes by Albert Bierstadt and Thomas Moran portray the "lure," while many other artists recorded the excitement of the Gold Rush, the railroads, and westward migration.

The changing view of Native American culture can be seen through the eyes of George Catlin and Charles Bird King, Eanger Irving Couse, and Olin Warner Levi. And by the 1890s, members of the Taos Society of Artists began to romanticize the rugged landscapes and the rich Hispanic cultures of the Southwest, which they valued as a place of primal beauty and spiritual values.

The Smithsonian American Art Museum is planning for a brilliant future in the new century. Our galleries will be expanded so that more art than ever will be on view, and in an adjacent building, we are opening a new American Art Center—a unique resource for information on America's art and artists, staffed for public use. We are also planning new exhibitions, sponsoring research, and creating educational activities to celebrate American art and understand our country's story better.

Elizabeth Broun
Director
Smithsonian American Art Museum

KENNETH M. ADAMS

1897–1966

Juan Duran

about 1933–34, oil
101.9 x 76.5 cm
Smithsonian
American Art
Museum

At age twenty-seven, Kenneth Adams became a member of the Taos Society of Artists, after having trained at the Art Students League of New York. Adams specialized in unsentimental images of the Spanish people of the Taos region, and this fine portrait shows his great skill.

The lighting on Duran's face, which forces him to squint, and on his rumpled shirt and multicolored plaid jacket is impressive. Up close you can see the contrasting strokes of bright paint that form a patchwork effect on the canvas. But if you stand back, these patches form islands of light and dark that are totally convincing. Crisscrossed brush strokes and overlapping tones give this work a cubist feel and make the subject seem thoroughly modern and fresh almost seventy years after he was immortalized by the artist.

Transfer from the U.S. Department of Labor

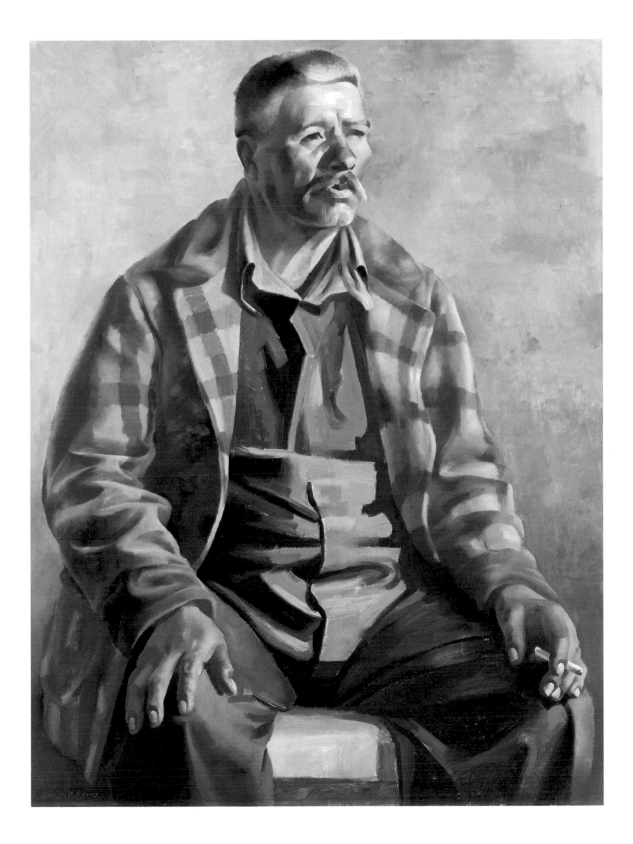

BRYANT BAKER

1881–1970

Pioneer Woman

modeled 1927,
cast 1968, bronze
81.3 x 37.8 x 41.1 cm
Smithsonian
American Art
Museum, Gift of
the artist

She strides ahead with purpose and conviction, leading her young son by the hand. He struggles and seems to gesture questioningly to no one in particular. They are heading into unknown territory with only a Bible and a small satchel of belongings. But the upright stature and confident stride of the woman convey anything but apprehension. You feel that they will conquer the obstacles to reach their destination.

This sculpture won an unusual competition in 1926, sponsored by oil magnate E. W. Marland. Marland invited twelve sculptors to submit models for a monument to the pioneer woman to be erected in Ponca City, Oklahoma. The models were shipped to sixteen cities throughout the United States, where visitors were invited to cast ballots for their choices. Bryant's *Pioneer Woman* took the popular vote—winning in eleven cities. The final monument, completed after this model, stands seventeen feet tall on a thirteen-foot base. Dedicated on April 22, 1930, it is inscribed, "In appreciation of the heroic character of the women who braved the dangers and endured the hardships incident to the daily life of the pioneer and homesteader in this country."

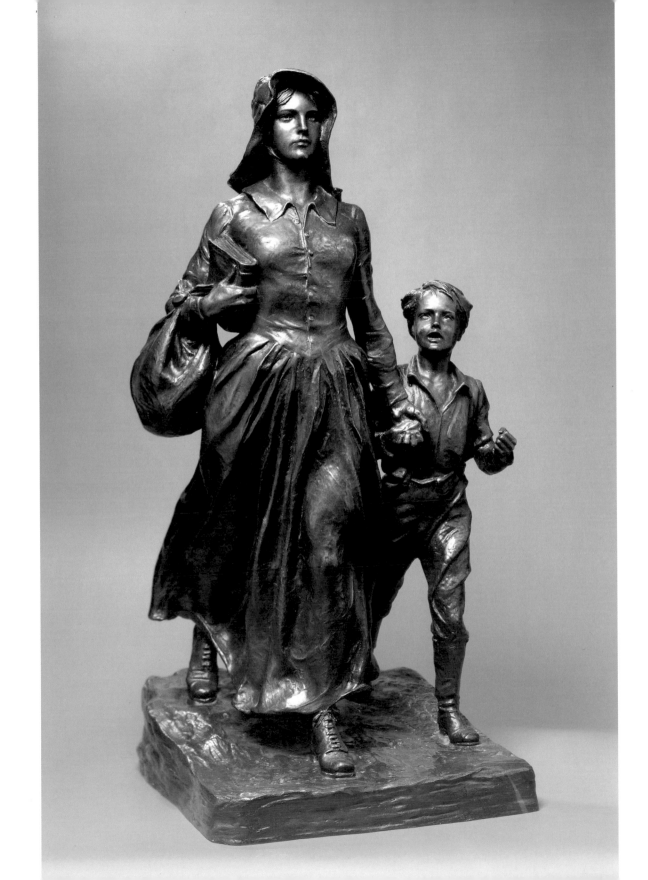

OSCAR EDMUND BERNINGHAUS

1874–1952

Red Pepper Time

about 1930, oil
63.5 x 76.4 cm
Smithsonian
American Art
Museum, Gift of
Arvin Gottlieb

In 1899, Oscar Berninghaus was commissioned by the Denver and Rio Grande Railroad to illustrate its advertisements. This work took him to the Southwest. He spent every summer there, finally settling in Taos in 1925. Berninghaus believed that "the canvases that come from Taos are as definitely American as anything can be. We have had French, Dutch, Italian, German art. Now we must have American art."

The artist must have been impressed with the red chili peppers hanging against the muted tones of native homes in Lavacita, New Mexico. Like royal robes, they give the sleepy town a luster and dignity, becoming rich flags for the rustic dwellings. Two native women walk up the dirt road toward us, but our eye can't keep up with their progress. We keep focusing on those peppers, surely a source of pride and beauty—as well as seasoning—for the villagers.

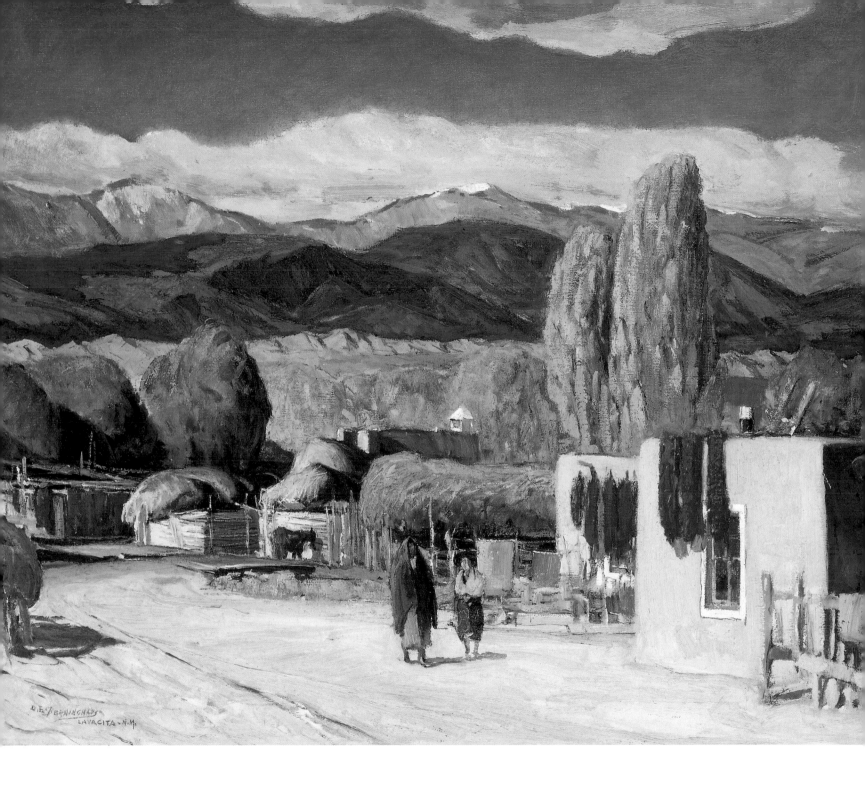

ALBERT BIERSTADT

1830–1902

Alaskan Coast Range

about 1889, oil
35.2 x 49.2 cm
Smithsonian
American Art
Museum,
Gift of Orrin
Wickersham June

The stillness and perfection of Bierstadt's canvases motivated one of his contemporaries to comment on his idealized vision of nature: "It is a perfect type of idea of what our scenery ought to be, if it is not so in reality." Bierstadt often made the natural wonders of North America look more like the Alps of his native Germany, where, in fact, he sometimes produced these works. But though the artist controlled and manicured nature for the entertainment of his audience, he never diminished its grandeur and power to impress. His images were, for many Americans, the only sense they had of what lay beyond the Mississippi River.

The snowy peaks in this painting appear truly Alpine, distanced from the viewer by a wide expanse of water in the foreground. The artist gives us room to be suitably awestruck with the spectacle on the horizon. It is scenery to be appreciated from afar. We are invited to marvel at the sublime creations of nature.

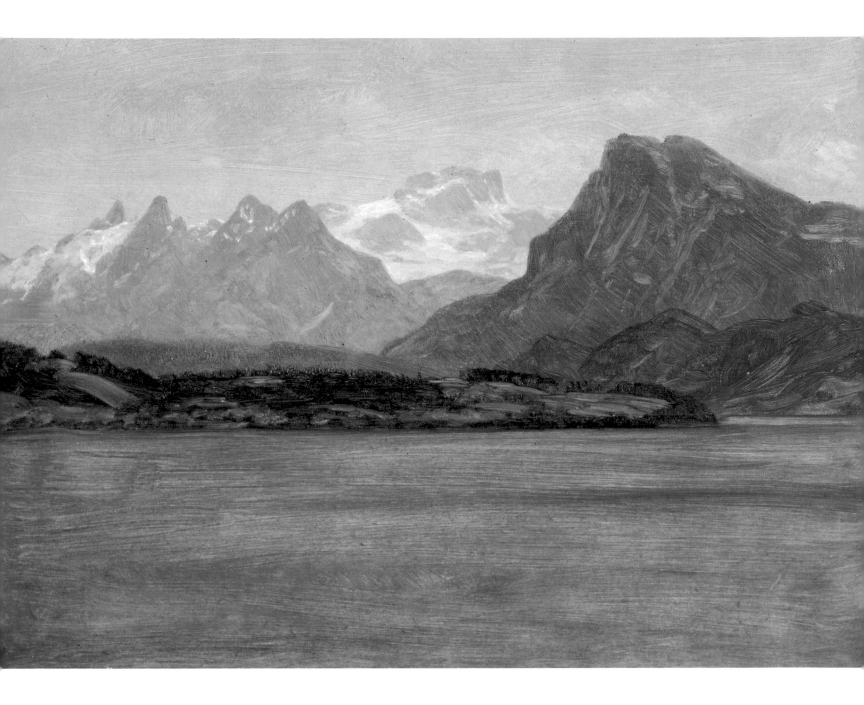

ALBERT BIERSTADT

1830–1902

Sunrise in the Sierras

about 1872, oil
34.3 x 47.9 cm
Smithsonian
American Art
Museum,
Gift of Orrin
Wickersham June

Bierstadt was clearly going for drama in this extraordinary painting in which the early morning light on the mountain range exhibits a spiritual quality. A master at manipulating a scene to display the sublime, the painter's artistic career soared to glorious heights with images such as this. He produced works at this scale in order to facilitate the demand for reproduction. Amazingly popular in his own time, Bierstadt's paintings remain American masterpieces. They retain for us a sense of the unspoiled beauty of the early West.

Bierstadt first experienced the West as a member of Colonel Frederick Lander's expedition to Wind River country in 1859. He claimed that the West furnished "the best material for the artist in the world."

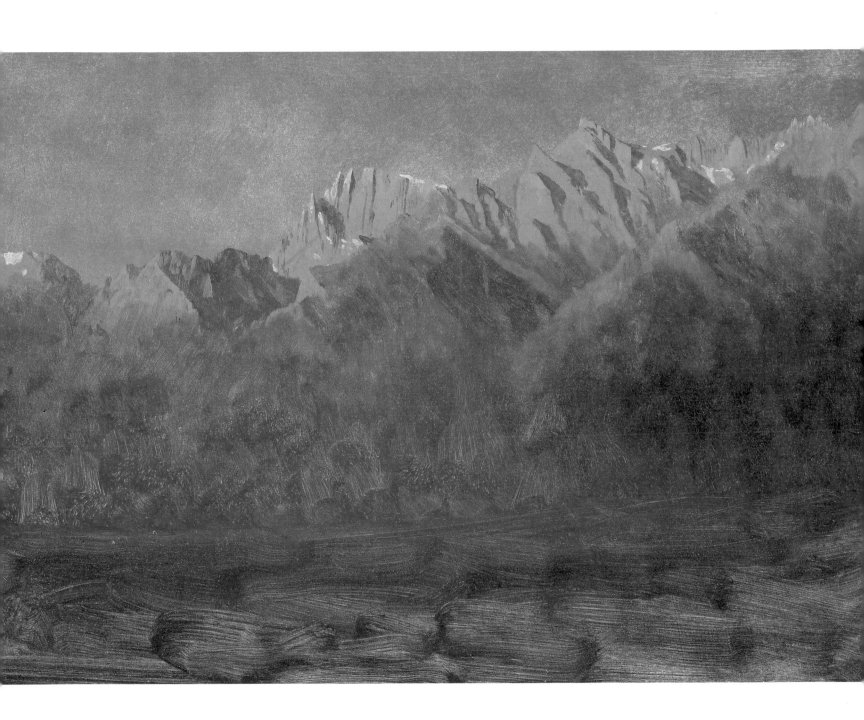

ALBERT BIERSTADT

1830–1902

Among the Sierra Nevada, California

1868, oil
183 x 305 cm
Smithsonian
American Art
Museum

Bequest of Helen
Huntington Hull,
granddaughter
of William Brown
Dinsmore, who
acquired the
painting in 1873
for "The Locusts,"
the family estate
in Dutchess County,
New York

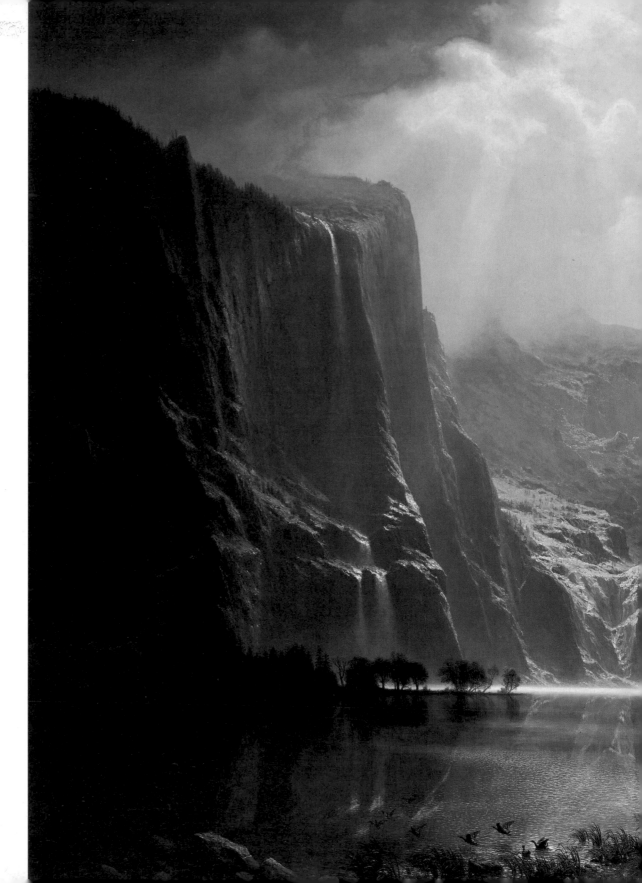

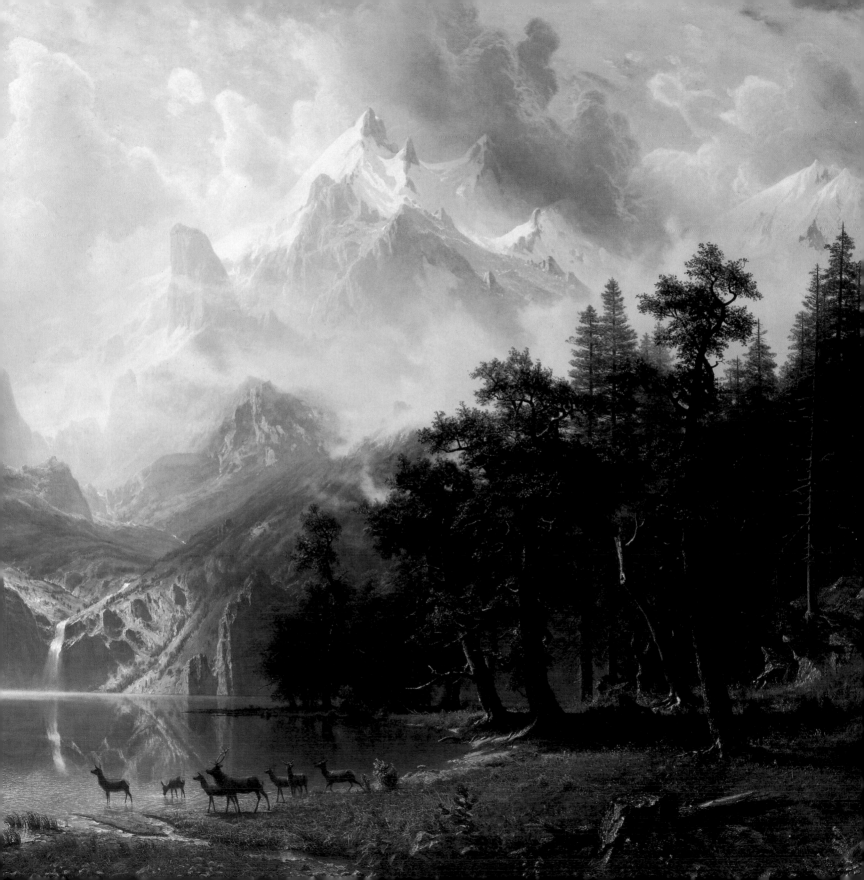

ERNEST L. BLUMENSCHEIN

1874–1960

The Gift

1922, oil
102.7 x 102.1 cm
Smithsonian
American Art
Museum

Blumenschein knew he was charting new territory in his early images of Taos: "No artist ever recorded the New Mexico I was now seeing. No writer had ever written down the smell of the air or the feel of the morning's sky." And few artists could convey the natural landscape around Taos better than Ernest Blumenschein.

His wonder for the place is felt in this large canvas in which a stern Native American woman looks past the viewer. She stands before the wildly patterned foliage of a tree, whose boughs hang low to the ground. What exactly is the gift she offers? She is wary and guarded; her arms are folded and a blanket is draped about her protectively. A young girl at right casts a sidelong glance, but the other women in the painting huddle in a circle, their backs to the viewer. They are not participants in this exchange.

Bequest of Henry Ward Ranger through the National Academy of Design

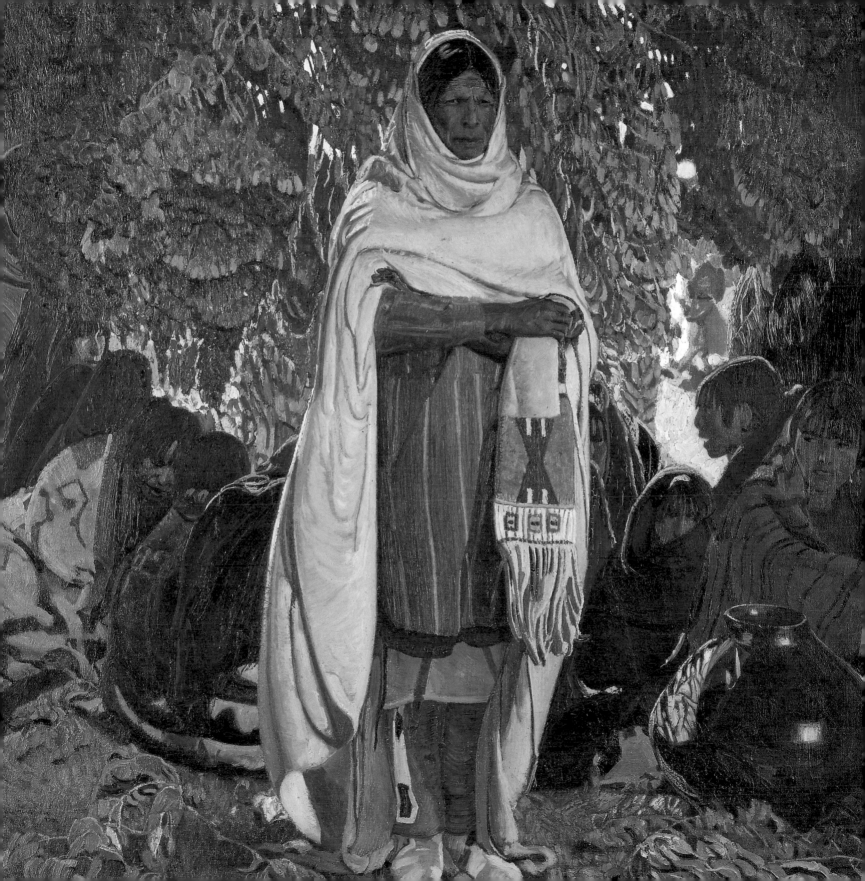

ERNEST L. BLUMENSCHEIN

1874–1960

Picuris Mountain (Near Taos)

about 1940, oil
26.1 x 64.4 cm
Smithsonian
American Art
Museum, Gift of
Arvin Gottlieb

Blumenschein wrote passionately about the Taos landscape and village. "I cannot describe my powerful impressions of the beauty of the color, the exotic charm of the place, the simple, long lines in the buildings, and rhythmic construction of the mountains. Perhaps my painting can convey what I felt. The finer emotions I try to express are impossible for me to explain in words. Let me, instead, write only of the painting method I use: When I get a 'jolt' from Nature, I know from many experiences that I must study the reasons in order to pass it along in a picture. It is not a matter of putting up your easel and copying the scene. It is far deeper. Perhaps I didn't exactly see the scene, but am affected more by the light, or the drama, or whatever you want to call it. Anyway, I have to get right down to the earth and analyze, to find out what makes the music."

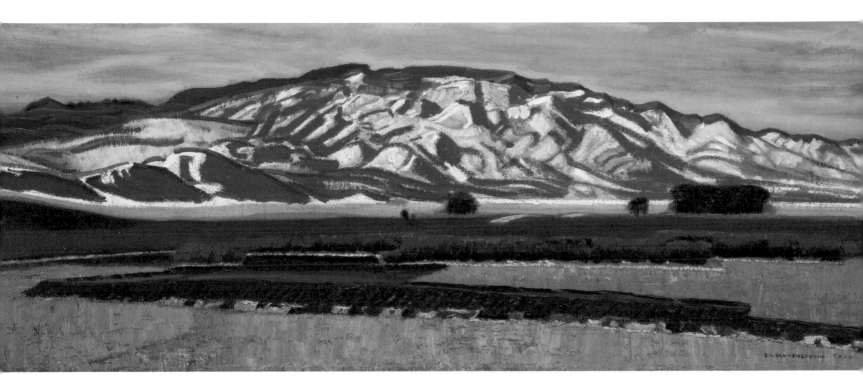

ELBRIDGE AYER BURBANK

1858–1949

each painting:
1904, oil
about 33 x 23 cm
Smithsonian
American Art
Museum,
Bequest of
Victor Justice
Evans

These four images of men and women from the Hopi and Tewa tribes of Arizona are marvelous studies. Burbank may have primarily intended to document the facial features and clothing of native inhabitants, but these small canvases also convey a quiet dignity and peacefulness that perhaps was unexpected by many Easterners.

The red used by Burbank for Pah-lah-wool-ey's shirt, Ho-me-hep-no-my's wrap, and Poe-shom-ee's and A-a-wah's loose-fitting mantles is as rich as blood. The women's hair glistens; the men's strong cheekbones shine. Each figure is set on a silvery gray background, with the exception of Poe-shom-ee, whose backdrop is slightly warmer. Textured brush strokes throw light on Burbank's subjects, highlighting their beauty.

The Harvard-educated Burbank studied at the Chicago Academy of Design and spent a brief period in Europe before returning to Chicago to open his own studio. His first commission was for *Northwest Magazine*, for which he painted views of the Northern Pacific Railway. But in the late 1890s, his career took a different path when his uncle, Edward Everett Ayer, president of the Field Museum of Natural History in Chicago, commissioned him to paint portraits of prominent Native Americans, among them Chief Geronimo. Burbank went on to paint more than 1,200 likenesses of native peoples, representing more than one hundred tribes.

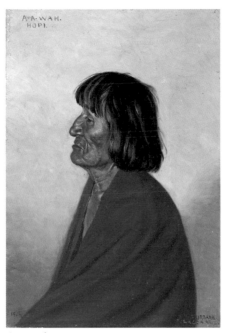

A-a-wah

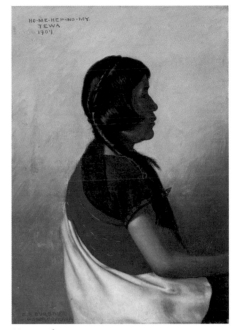

Ho-me-hep-no-my

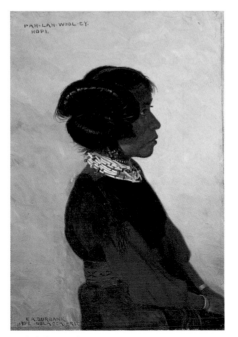

Pah-lah-wool-ey

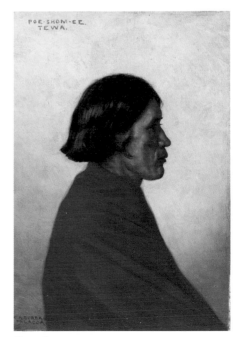

Poe-shom-ee

GEORGE CATLIN

1796–1872

Ball-play of the Choctaw–Ball Up

1834–35, oil
49.6 x 70 cm
Smithsonian
American Art
Museum, Gift of
Mrs. Joseph
Harrison Jr.

Once you look carefully, what at first appeared to be chaos is actually a kind of organized sport, perhaps something like our modern-day lacrosse. Hundreds of scantily clad bodies charge at one another across a lush green plain that presents an Eden-like serenity. The perspective is marvelous, with bodies blurring together at the horizon of this panoramic view.

Catlin conveys the joyful pandemonium of this Choctaw ritual. He explained, "In the game every player was dressed alike, that is *divested* of all dress, except the girdle and the tail . . . and in these desperate struggles for the ball, when it is *up* (where hundreds are running together and leaping, actually darting between their adversaries legs, tripping and throwing, and foiling each other in every possible manner, and every voice raised to the highest key, in shrill yelps and barks!) there are rapid successions of feats, and of incidents that astonish and amuse far beyond the conception of any one who has not had the singular good luck to witness them."

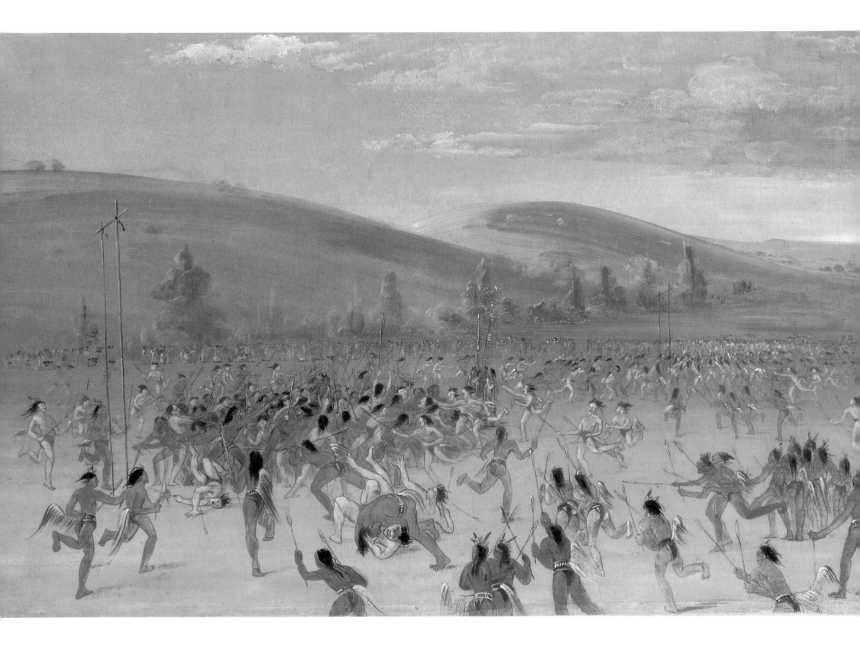

GEORGE CATLIN

1796–1872

Catlin and His Indian Guide Approaching Buffalo under White Wolf Skins

1846–48, oil
50.9 x 69.2 cm
Smithsonian
American Art
Museum, Gift of
Mrs. Joseph
Harrison Jr.

Catlin and his Indian guide, who appear disguised in wolf skins, advance cautiously on a buffalo herd. Catlin carefully studied methods of stalking and killing buffalo, but he also expressed a sincere concern for the diminishing herds and hoped to document their critical role in Native American life. His hopes are expressed in the composition through the extension of the herd over the expansive green plains as far as the eye can see merging with the blue horizon.

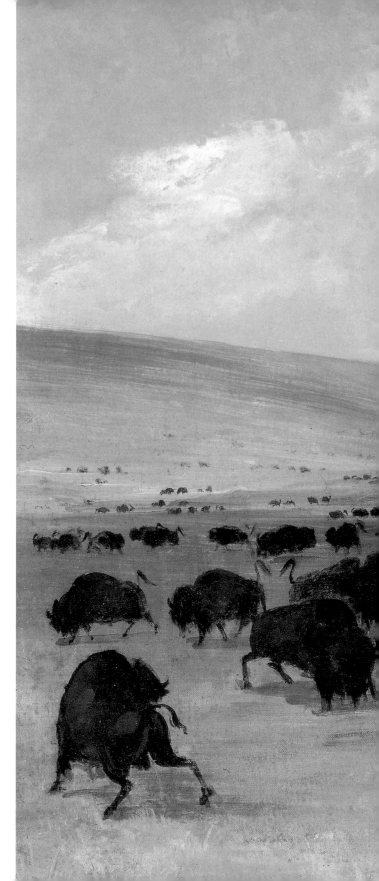

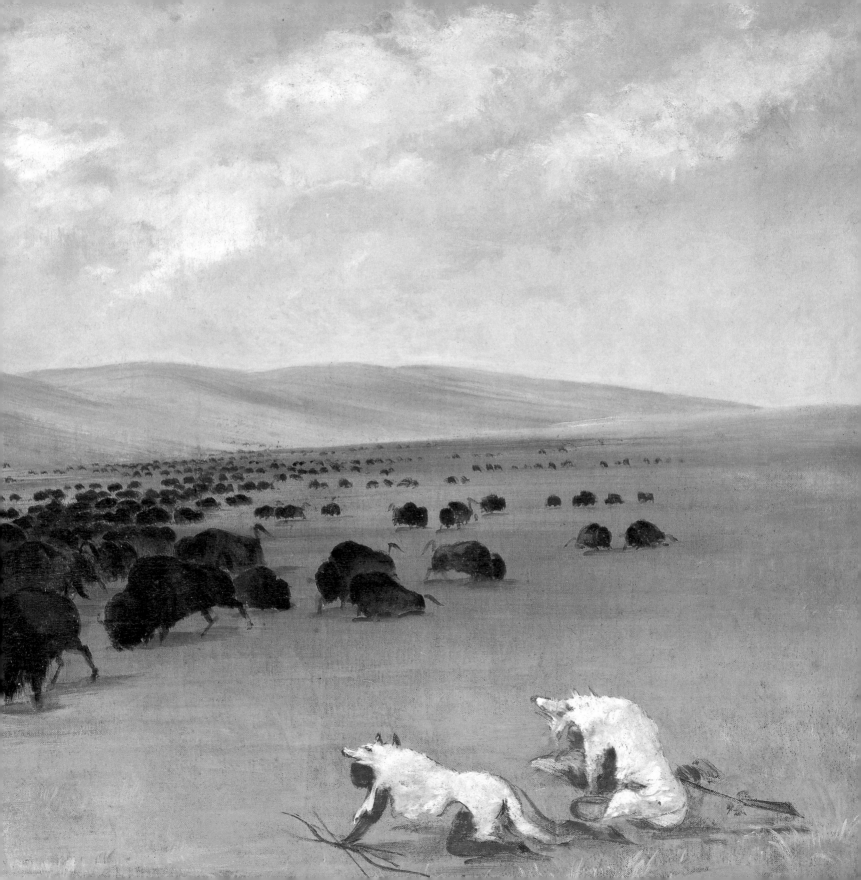

GEORGE CATLIN

1796–1872

Comanche Moving Camp, Dog Fight Enroute

1834–35, oil
49.8 x 70 cm
Smithsonian
American Art
Museum, Gift of
Mrs. Joseph
Harrison Jr.

An outright brawl is the lively subject of this painting, in which the pressures of moving camp have led squaws and dogs to vent their anxieties. The artist captures the sense of commotion with his depiction of figures rushing together from the far sides of the camp. Catlin was a spectator of the actual event and felt fortunate to produce "a sketch of one of these extraordinary scenes, which I have had the good luck to witness; where several thousands were on the march, and furnishing one of those laughable scenes which daily happen, where so many dogs, and so many squaws, are traveling in such a confused mass; with so many conflicting interests, and so many local and individual rights to be pertinaciously claimed and protected. Each horse drags his load, and each dog, i.e. each dog that *will* do it (and there are many that will *not*), also dragging his wallet on a couple of poles; and each squaw with her load, and all together (notwithstanding their burthens) cherishing their pugnacious feelings, which often bring them into general conflict, commencing usually amongst the dogs, and sure to result in fisticuffs of the women, whilst the men, riding leisurely on the right or left, take infinite pleasure in overlooking these desperate conflicts, at which they are sure to laugh, and in which they are sure never to lend a hand."

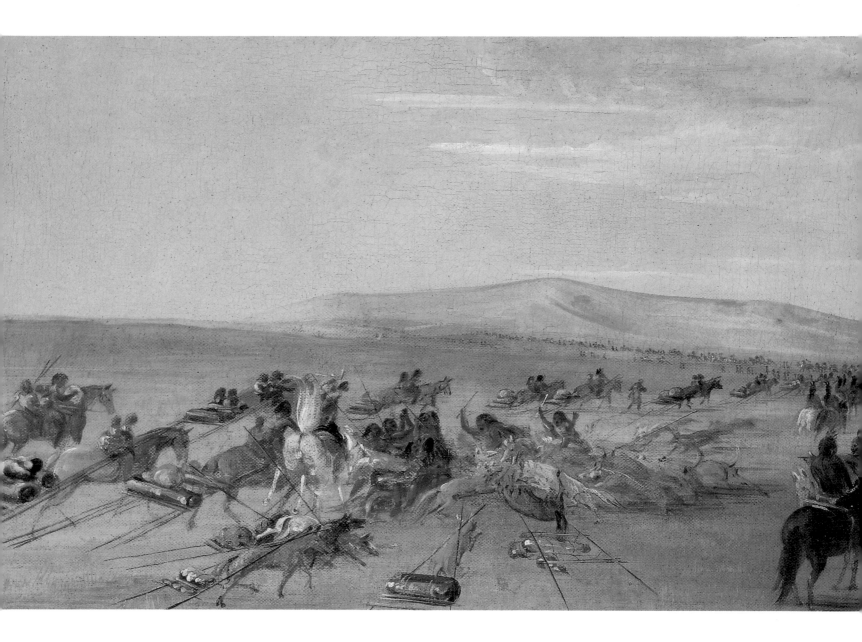

GEORGE CATLIN

1796–1872

Comanche Village, Women Dressing Robes and Drying Meat

1834–35, oil
50.9 x 69.3 cm
Smithsonian
American Art
Museum, Gift of
Mrs. Joseph
Harrison Jr.

Catlin visited this Comanche village, located in present-day Oklahoma at the foot of the Wichita Mountains, in 1834. He recorded his impressions: "The village of the Comanchee . . . is composed of six or eight hundred skin-covered lodges, made of poles and buffalo skins, in the manner precisely as those of the Sioux and other Missouri tribes. . . . This village with its thousands of wild inmates, with horses and dogs, and wild sports and domestic occupations, presents a most curious scene; and the manners and looks of the people, a rich subject for the brush and the pen."

This canvas reveals the daily life of Comanche women, who set about their task of drying meat and dressing buffalo hides on racks. The painting has a hasty, almost sketchy quality, perhaps because of Catlin's urgent desire to capture every activity he observed. Still, it serves as an arresting document of activities in a Native American encampment.

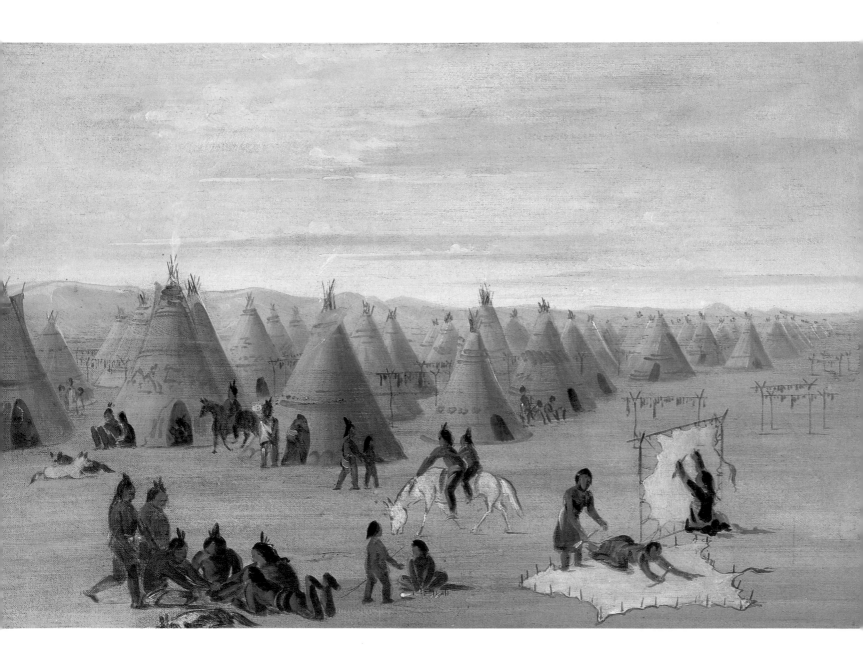

GEORGE CATLIN

1796–1872

Dying Buffalo Bull in a Snowdrift

1837–39, oil
50.9 x 69.4 cm
Smithsonian
American Art
Museum, Gift of
Mrs. Joseph
Harrison Jr.

Catlin experienced the buffalo hunt firsthand and understood its dangers. He recounted an experience at the mouth of the Yellowstone: "Amidst the trampling throng, Monseigneur Chardon had wounded a stately bull, and at this moment was passing him again with his piece levelled for another shot; they were both at full speed and I also, within reach of the muzzle of my gun, when the bull instantly turned and receiving the horse upon his horns, and the ground received poor Chardon, who made a frog's leap of some twenty feet or more over the bull's back, and almost under my horse's heels."

Dying Buffalo Bull in a Snowdrift is one of the most poignant of Catlin's images of Native American cultures. A wounded buffalo's blood seeps into the frozen ground. An Indian—his pursuer and killer—lies motionless next to him. The brave's headdress and bow are scattered on the ground. The scene is a reminder of the risk and loss inherent in the Native American's way of life.

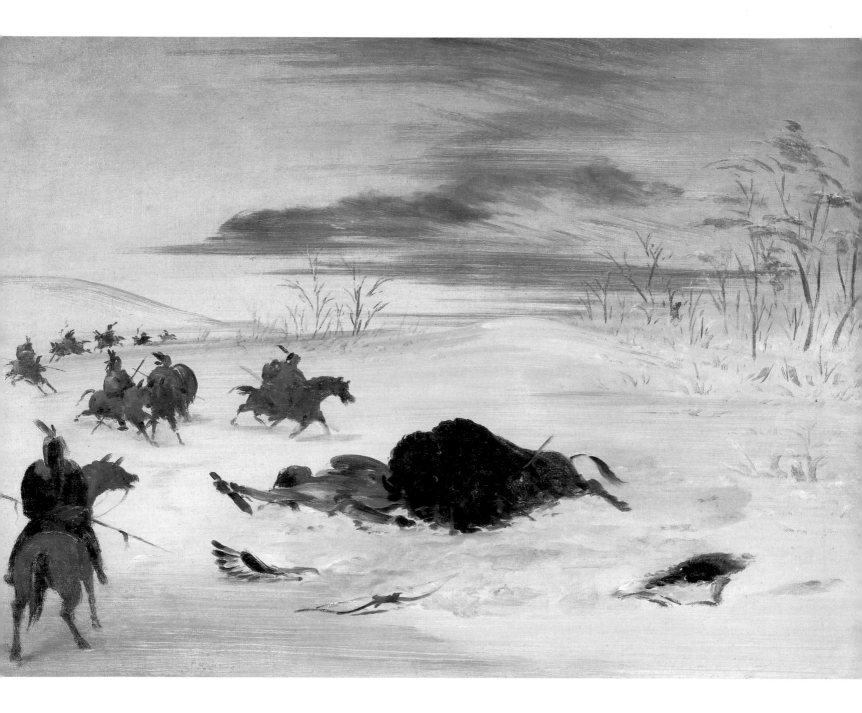

GEORGE CATLIN

1796–1872

View on the St. Peter's River, Sioux Indians Pursuing a Stag in Their Canoes

1836–37, oil

49.5 x 70.1 cm

Smithsonian
American Art
Museum, Gift of
Mrs. Joseph
Harrison Jr.

Sioux Indians pursue a stag across a pristine lake, an image that symbolized for Catlin the free and unfettered existence of the tribes he visited out West. The Indian represented the spirit of what he called "the great and almost boundless garden-spot of earth," and his canvases present a detailed yet idealized view of Native American culture.

This image draws us into the action. We follow the prows of the canoes and the barrels of the hunters' rifles, all of which are aimed at the head of the stag, which is attempting to swim to safety at a spot beyond the picture plane. The armed men stand in their canoes, their bodies arching forward in anticipation of the kill. One hunter has fired his gun, but does not recoil from its retort. He is calm, focused, and intent on the hunt.

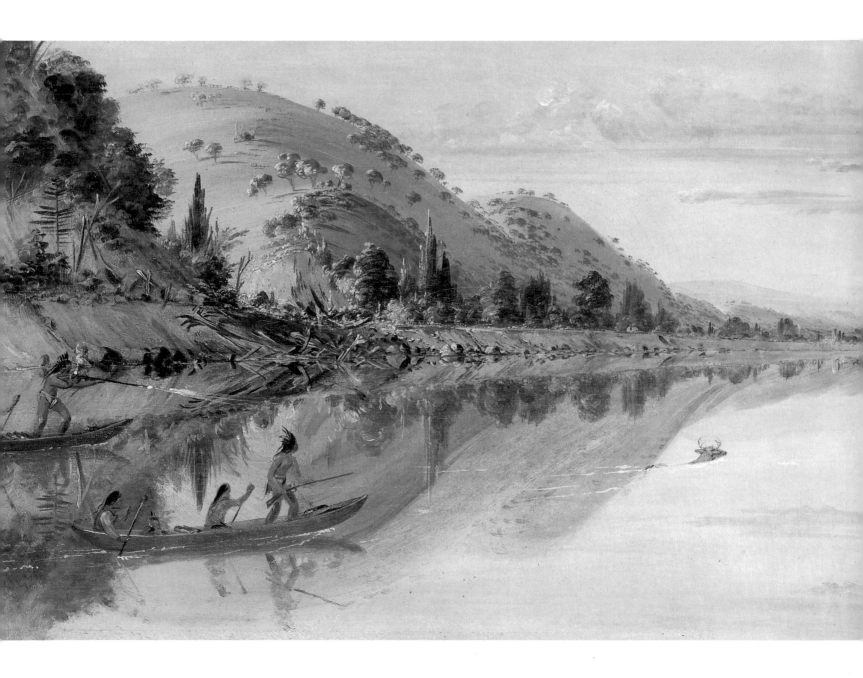

GEORGE CATLIN

1796–1872

each painting:
oil, 73.7 x 60.9 cm
Smithsonian
American Art
Museum, Gift of
Mrs. Joseph
Harrison Jr.

While Catlin painted many bust-length portraits, these four canvases are rarer full-length figures. We know from Catlin's writings that Mick-e-no-páh, a Seminole chief, was a stubborn subject, refusing to be painted at first and only reluctantly agreeing on the condition that his red leggings be included in the composition. The artist obliged and actually painted in the legs first, saving room for the torso and head above.

Midday Sun, a descendant of a Hidatsa chief, is, as Catlin put it, "a fair sample" of the beautiful girls of that tribe. According to the painter's account, her proud relatives encouraged her to pose—although she protested that she was not beautiful enough. He was equally pleased to have the opportunity to depict her lovely costume of mountain-sheep skin decorated with beads and porcupine quills.

Catlin noted that Black Rock, a Western Sioux who was highly respected by fur traders, was "a tall and fine looking man, of six feet or more in stature." His long headdress is made of war-eagles' quills and ermine skins. His stance is regal, with robe thrown over his shoulders and spear extended.

More puzzling is The Cheyenne, a Republican Pawnee, who holds a whip in one hand and a pipe in the other. His mouth appears sealed with a painted handprint, which draws the viewer's attention away from the shiny medallion around his neck. We can see Catlin's sure touch in the colored stripe decorating the fringed leggings, which remain unfinished together with the landscape setting and the blanket covering the lower half of the figure.

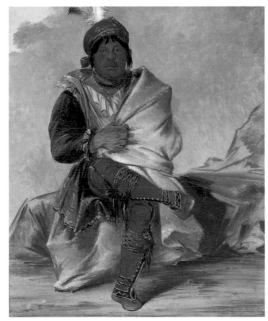

Mick-e-no-páh, Chief of the Tribe, 1838

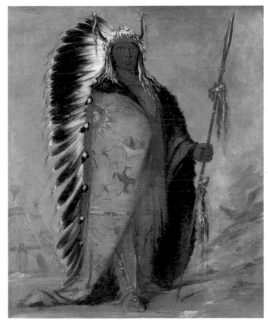

Black Rock, a Two Kettle (?) Chief, 1832

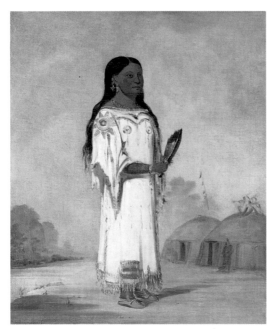

Midday Sun, a Pretty Girl, 1832

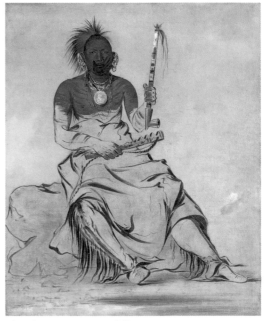

The Cheyenne, a Republican Pawnee, 1832

GEORGE CATLIN

1796–1872

each painting:
oil, 73.7 x 60.9 cm
Smithsonian
American Art
Museum, Gift of
Mrs. Joseph
Harrison Jr.

When George Catlin first saw a delegation of Native Americans, which was passing through Philadelphia in the late 1820s, he was moved to give up his law career and vowed that "nothing short of loss of my life shall prevent me from visiting their country and becoming their historian." Catlin's deeper motivations can only be imagined. Surely he was ambitious and had a commercial interest in documenting Indian life. But it is apparent that he also felt a genuine sympathy and awe for the tribes he encountered in his six years in the American West.

These four portraits reveal Catlin's sensitivity to his subjects, who are portrayed as dignified in bearing. Catlin remembered The Wolf as "a chief of some distinction, with a bold and manly outline of head." Catlin was obviously impressed by the chief's curiously ornamented headdress and the elaborate strings of wampum around his neck. Male Caribou also sports intriguing headgear, an animal hide peeking out from his shirt, and a huge war club. Catlin referred to Co-ee-há-jo as a great warrior. He holds his rifle securely, never taking his eyes from the viewer's. Wild Sage, perhaps painted by Catlin because she was "exceedingly pretty in feature and form," wears a traditional Wichita gown.

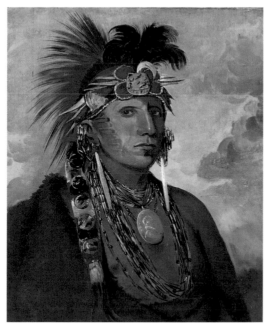

The Wolf, a Chief, 1832

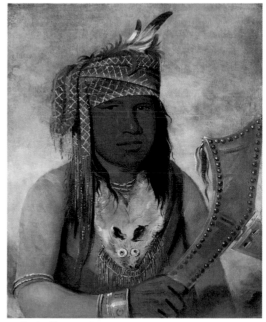

Male Caribou, a Brave, 1836

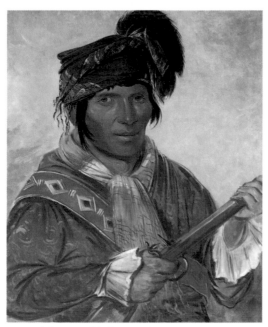

Co-ee-há-jo, a Chief, 1838

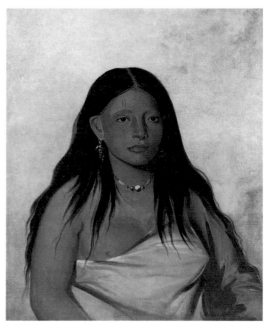

Wild Sage, a Wichita Woman, 1834

GEORGE CATLIN

1796–1872

each painting:

oil, 73.7 x 60.9 cm

Smithsonian
American Art
Museum, Gift of
Mrs. Joseph
Harrison Jr.

Of the serious-looking Téh-tóot-sah, Catlin wrote, "The head chief of the Kioways . . . we found to be a very gentlemanly and high minded man. . . . His long hair, which was put up in several large clubs, and ornamented with a great many silver broaches, extended quite down to his knees." The somewhat faraway look in Mad Buffalo's eyes might reflect his plight. Catlin noted in his letters that Mad Buffalo "was tried and convicted for the murder of two white men during Adams' administration, and was afterwards pardoned, and still lives, though in disgrace in his tribe, as one whose life has been forfeited."

These images, part of Catlin's successful "Indian Gallery," which he exhibited after returning East, toured along with actual Native Americans and their artifacts. His tour proved excessive in ambition, and Catlin had exhausted his finances by the mid-1850s. He was eventually supported by a wealthy patron, Joseph Harrison, and maintained for a time in his old age a studio in the Smithsonian Castle. Following his death, 445 paintings from his "Gallery" were donated to the Smithsonian Institution.

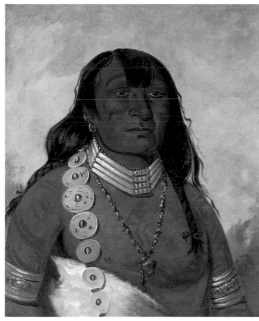

***Téh-tóot-sah (Better Known as Tohausen,
Little Bluff), First Chief,*** 1834

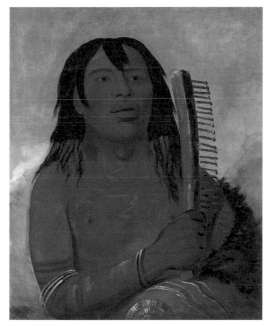

Bear's Child, 1832

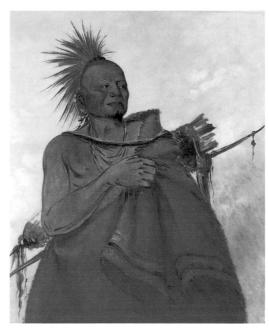

Mad Buffalo, Murderer of Two White Men, 1834

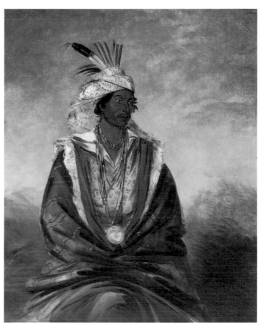

Tel-maz-há-za, a Warrior of Dis 'inction, 1834

NORMAN S. CHAMBERLAIN

1887–1961

Corn Dance, Taos Pueblo

1934, oil
127.5 x 102.1 cm
Smithsonian
American Art
Museum

Like a natural bull's-eye, a corn husk lies in a central circle, about which villagers of this native pueblo gather. The women at left hold ears of corn as offerings, and the men, painted like spotted cattle and carrying maracas, seem poised in mid-dance. These men are painted clowns from the Koshare Society cult and represent the spirits of the dead. Hooded figures in the foreground and background complete the circle. Held together by a landscape created by dotted brush strokes, which adds yet another pattern to an almost psychedelic mix, they all seem entranced by the marvelous corn. The ominous rose-hooded figure at bottom gazes out at us, his back turned to the scene. His drum is intended to wake up the clouds, bring rain, and cheer the villagers.

Chamberlain first attempted Indian subjects while working for the Public Works of Art Project in the 1930s.

Transfer from the U.S. Department of Labor

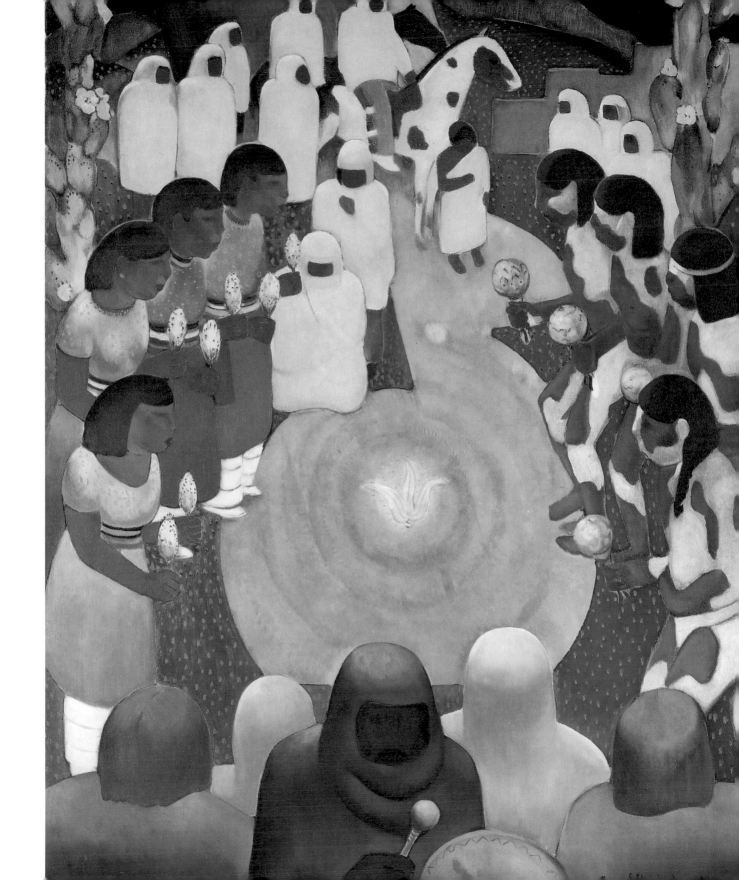

EANGER IRVING COUSE

1866–1936

Elk-Foot of the Taos Tribe

1909, oil
198.6 x 92.4 cm
Smithsonian
American Art
Museum, Gift of
William T. Evans

This is a romantic and imposing image. Elk-Foot, draped in an earthy red blanket, actually a fabric called "stroud," which was imported from England, appears royal and aloof. He looms above us, casting his eyes downward but to the side. He never makes eye contact, but seems to know we're here, although he is unmoved by our presence.

Among the first artists to work in Taos, Couse borrowed heavily from traditional academic sources. The angled head graced with vivid red feathers, the large hand spread across his lap, the parted robe revealing elaborately beaded and fringed boots, create a wonderful composition. We also sense a power here, perhaps emanating from Elk-Foot's coupstick. In his culture, the first warrior to strike an enemy with this stick was awarded a scalp.

This idealized portrait of Elk-Foot derives from a carefully posed studio photograph of the Taos native, who was one of Couse's favorite models. Critics today have focused on Couse's liberal license in depicting this warrior of the Taos tribe in moccasins of the Plains Indians as well as other inauthentic details, but this extraordinary canvas conveys the appeal of exotic Indian cultures, then attracting many tourists to the Southwest.

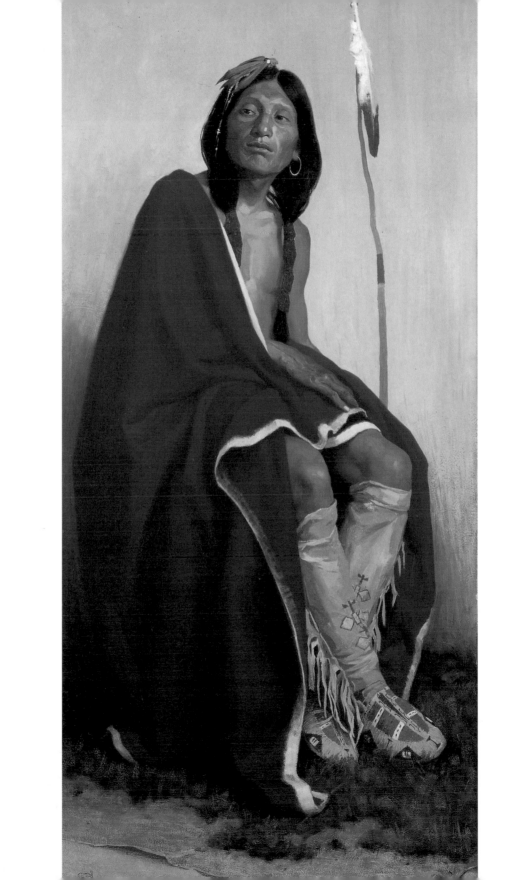

Indian Women Making Pottery

about 1924, oil
101.9 x 94.3 cm
Smithsonian
American Art
Museum, Gift of
Arvin Gottlieb

At the lower right, one native woman uses a fine brush—or perhaps a stick dipped in paint—to affix a geometric design on an earthenware vase. Seated behind her, a woman in a teal shirt and purple skirt grinds corn on a stone *metate*. Behind them on a stool, forming the peak of this triangular composition, a man looks beyond the canvas. An empty niche in the adobe wall waits to be filled with ceramic treasures, which—by 1924—would have been sold to eager tourists.

Critcher visited New Mexico for the first time in 1920 and was intrigued by the possibilities of portraying the Pueblo Indians and Spanish people. In 1924, she became the only female member of the influential Taos Society of Artists.

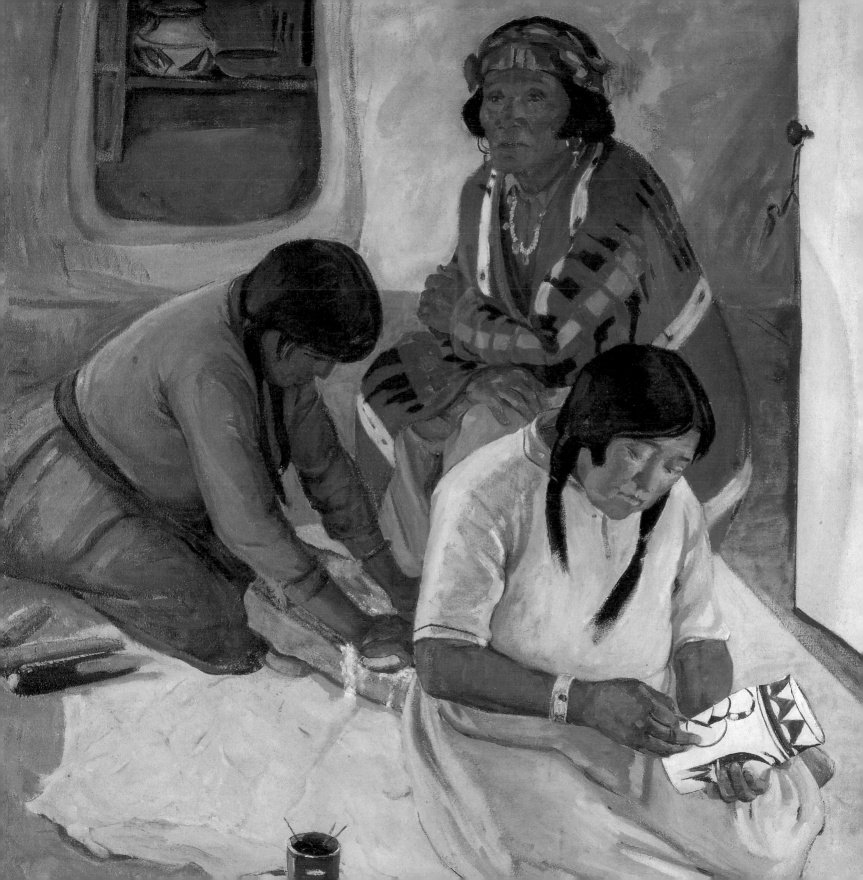

ANDREW DASBURG

1887–1979

Rolling Hills

after 1924, oil
33.3 x 41.1 cm
Smithsonian
American Art
Museum, Gift of
Arvin Gottlieb

Dasburg was born in Paris in 1887 but emigrated to the United States at an early age. He returned to Paris in 1910 to study art and was inspired by Cézanne and Matisse. He said, "I came back from Europe inflamed like a newly converted evangelist and I talked endlessly about what I had seen in experimental art."

Rolling Hills, executed soon after Dasburg's first visit to New Mexico, reveals the artist's attachment to modernist geometric form. The layout of the pueblo, with cubic structures and fields neatly set on a grid, contrasts with the more free-form mountains that dominate the horizon. Desert tones are tinged with blues and ochres.

Dasburg eventually made New Mexico his permanent home, dying there in 1979. His friend Ward Lockwood's words, written for an exhibition of Dasburg's work in 1957, still ring true: "He became the landscape and it became him. Together they shift, alter, grow, and become fused in the complex of form, space, and color that is painting."

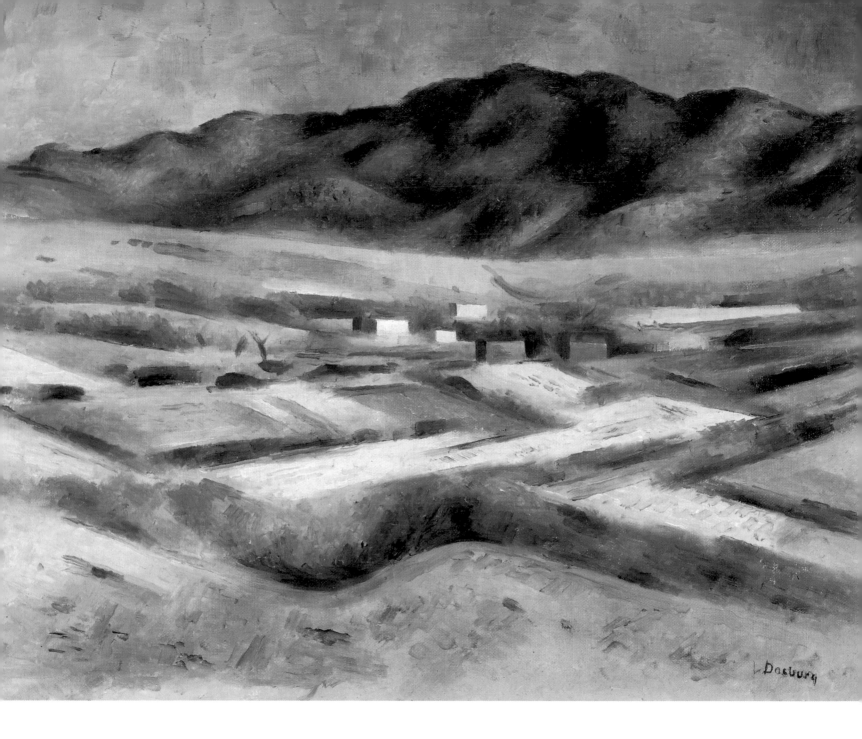

W. HERBERT DUNTON

1878–1936

Fall in the Foothills

about 1933–34, oil
86.4 x 106.8 cm
Smithsonian
American Art
Museum

At home in the wilderness, Dunton's bears are natural shapes that blend with the landscape. The large bear and two cubs in this painting are searching the ground for food. Tilted trees compactly frame them, creating a neat triangular composition.

Dunton was born in Maine but became intrigued with the American West. He belonged to the Taos Society of Artists and created works that communicated the romance and adventure of the region's wilderness. An avid fisherman and hunter, Dunton respected his prey. These bears, inquisitive and endearing, roam freely and unimpeded in a landscape absent of men, their guns, and their paint boxes.

Transfer from the U.S. Department of the Interior, National Park Service

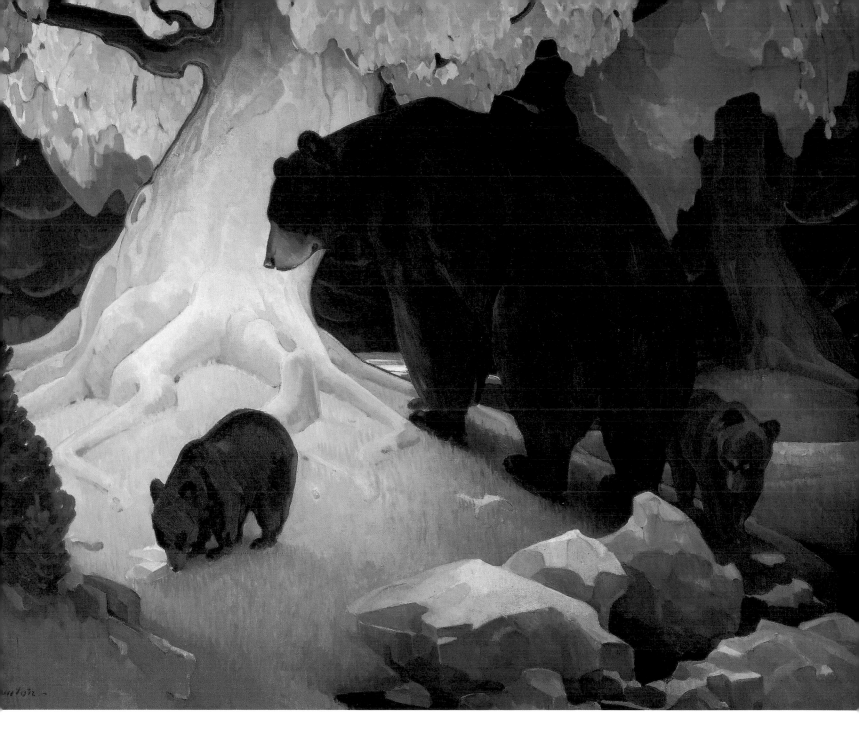

WILLIAM PENHALLOW HENDERSON

1877–1943

Feast Day: San Juan Pueblo

about 1921, oil

55.9 x 76.3 cm

Smithsonian

American Art

Museum

Henderson moved to Santa Fe in 1916 due to his wife's failing health. There he became an important member of the Taos Society of Artists, which had held its inaugural exhibition the year before. Here, with simple shapes and bold colors, Henderson documents a feast day in a Southwestern Pueblo settlement. We are looking down into a small plaza dominated by a simple church, whose angelic statues loom over the tree line toward the gathering in town.

Henderson conveys the vivid colors of the women's garments with visible brush strokes outlined in black. The houses are little more than orange-colored boxes splashed with yellow, rose, and green. Simple tree and mountain shapes make jagged steps right up to the top of the picture at right. That line gives the composition a grand perspective. We have the sense that we are looking down from a great height on the brilliant multitude gathered under the canopy to eat, listen to the lone drummer, and celebrate the mesmerizing landscape.

Like many of the artists who were entranced by New Mexico, Henderson was captivated by the lives of the local people, whose customs remained unchanged by progress.

Gift of Alice H. Rossin in memory of Dr. Joshua C. Taylor

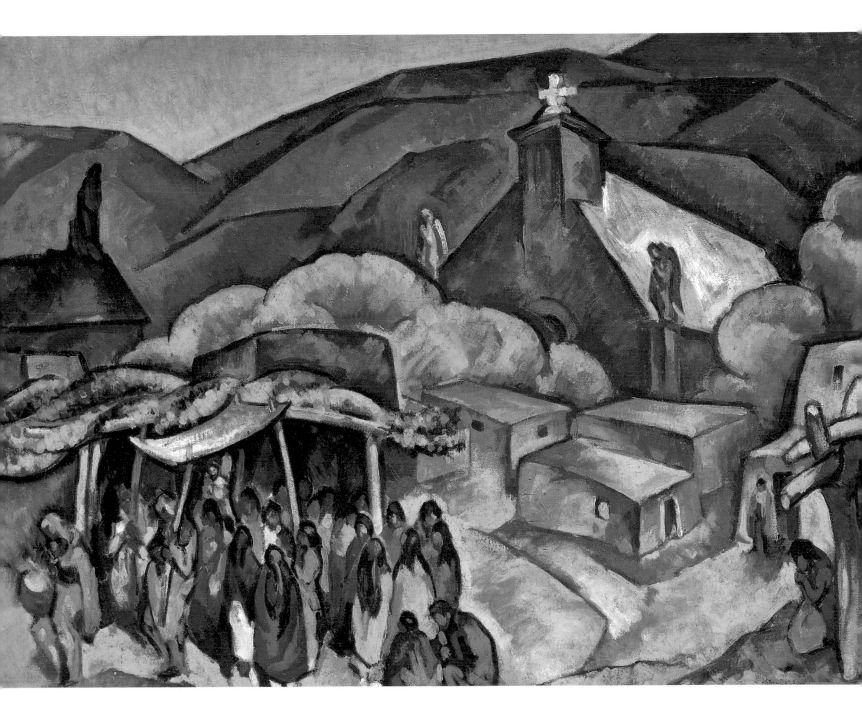

E. MARTIN HENNINGS

1886–1956

Homeward Bound

about 1933–34, oil
76.8 x 92.1 cm
Smithsonian
American Art
Museum

Two determined-looking native girls trudge through a snow-blanketed landscape on their way home. The top of the canvas is a brilliant yellow, although in this work it is a cool—even cold—color. At the horizon, vertical rose brush strokes and a terra-cotta building depict a settlement. Screening the women from the landscape, and making their destination seem harder to reach, are lattice-like bare branches with withered pods.

Hennings had a great love for New Mexico that is truly evident in his expressive paintings. He articulated his enthusiasm in no uncertain terms: "I have been working in Taos for many years and I think that should prove that I like it here; the country, the mountains with their canyons and streams, the sage beneath the clouded skies, the adobe village with its Spanish people, and of course, the Taos pueblo with its Indians."

Transfer from the U.S. Department of Labor

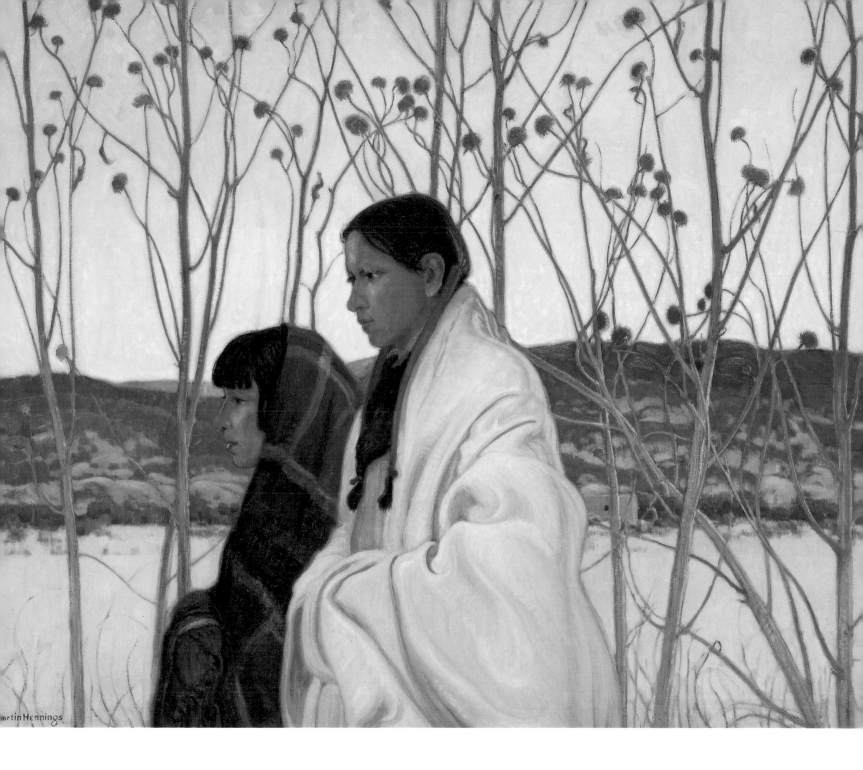

E. MARTIN HENNINGS

1886–1956

Riders at Sunset

1935–45, oil
76.2 x 91.7 cm
Smithsonian
American Art
Museum, Gift of
Arvin Gottlieb

Hennings's poetic style and bright palette defy categorization. He never felt himself to be part of a movement and asserted, "My standpoint is that art is either good or bad and its school has not a great deal to do with it. In every picture I expect the fundamentals to be observed, and these I term draftsmanship, design, form, rhythm, color. Art must of necessity be the artist's own reaction to nature and his personal style is governed by his own temperament, rather than by a style molded through the intellect."

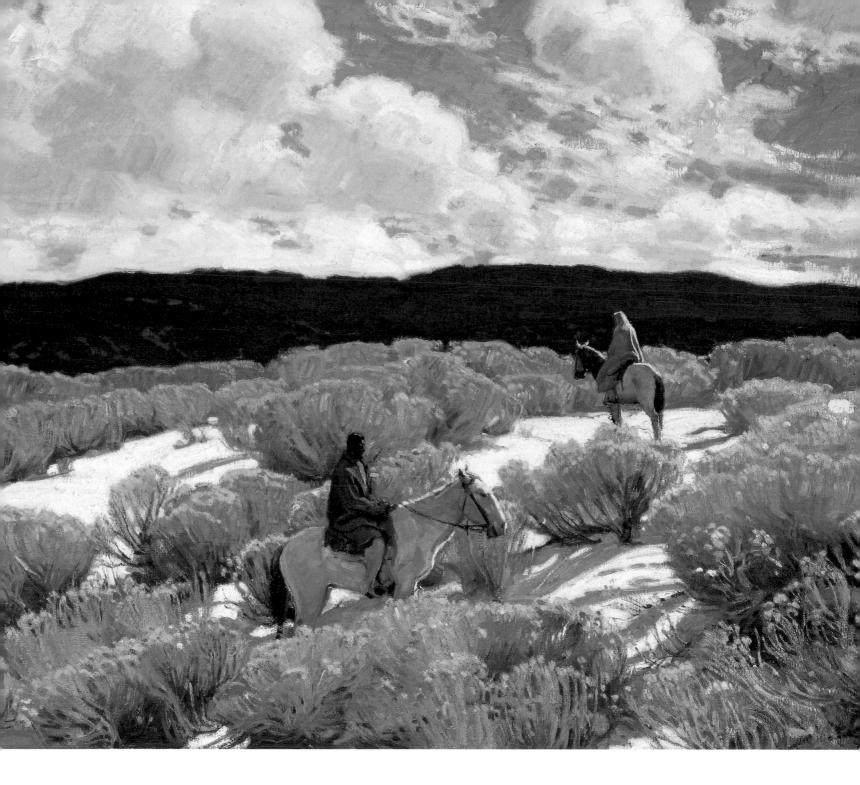

VICTOR HIGGINS

1884–1949

Mountain Forms #2

about 1925–27, oil
102.9 x 109.4 cm
Smithsonian
American Art
Museum, Gift of
Arvin Gottlieb

Rising and building in size, almost to the top of the canvas, these green and earth-colored mountains are "forms," shapes that when one stands back from the image become majestic in volume and scale. Tiny figures in single file are headed across a misty gorge toward those daunting heights. They are drawn to the mountains' abstract beauty, climbing over a slumbering beast toward a darker destination, perhaps on a religious pilgrimage.

Higgins divides his large triangular forms into "foothills" by using curving blue brush strokes to convey separate forms. The ragged geometry of the mountains and neutral sky pressing down create a tension.

This is one of five "Mountain Form" canvases that Higgins painted between 1924 and 1927. Only two still exist; the other three are known through photographs. All works place the spectator at an elevated vantage point, but only *Mountain Forms #2* contains a human element. Higgins cited the area's elemental appeal as his inspiration, saying it "urges the painter to get his subjects, his coloring, his tone from real life, not from the wisdom of the studios."

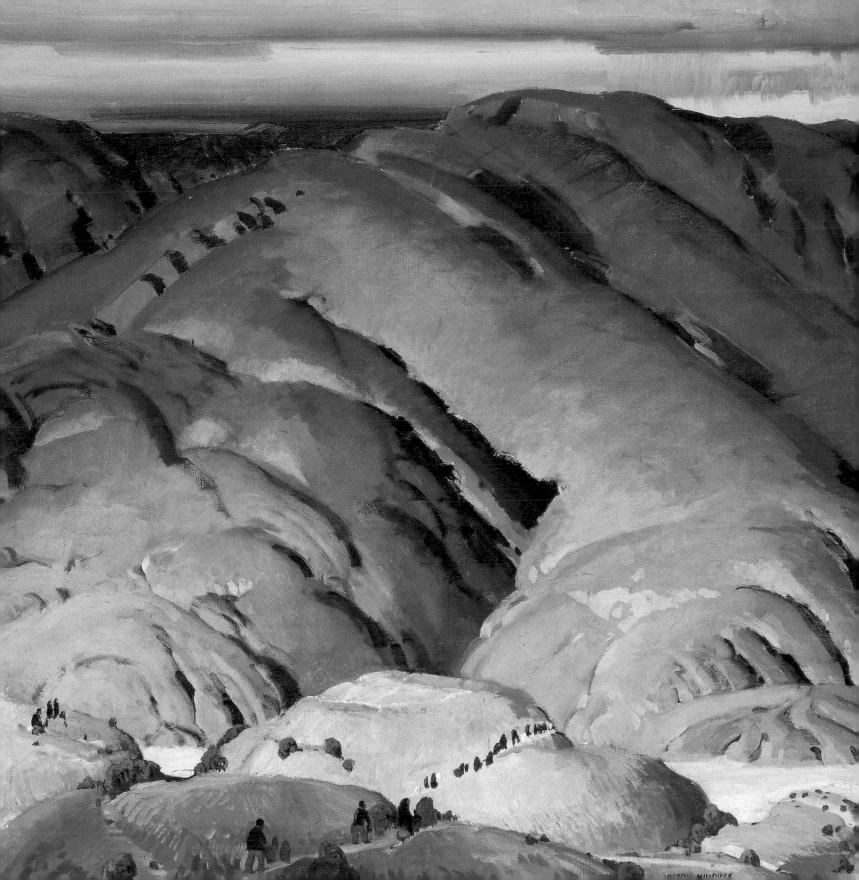

EDWARD KEMEYS

1843–1907

Bear

before 1907, bronze
28.6 x 31.1 x 19.4 cm
Smithsonian
American Art
Museum, Gift of
J. Willis Johnson

Kemeys was born in Savannah, Georgia, in 1843 and served as a captain in the Union Army during the Civil War. He had always been enamored of animals but had never been moved to make an image of one until, serving as an engineer on a party charged with laying out New York's Central Park, he saw a sculptor modeling a wolf's head at the zoo and decided to try his own hand.

This docile black bear is an accomplished result of Kemeys's artistic efforts. With paw raised and nose pointed inquisitively in the air, this diminutive animal is more pet than wild beast.

Kemeys had a certain style of his own, declaring in a public address in 1897: "The object of my school of sculpture is to perpetuate in enduring form the Indian types and fauna of North America, before they shall have utterly disappeared. . . . I set to work not a moment too soon, hunted the wild animals, and studied them, with the Indians and Trappers for my friends and helpers, and I can say without egotism that I am the pioneer sculptor of the animals of North America."

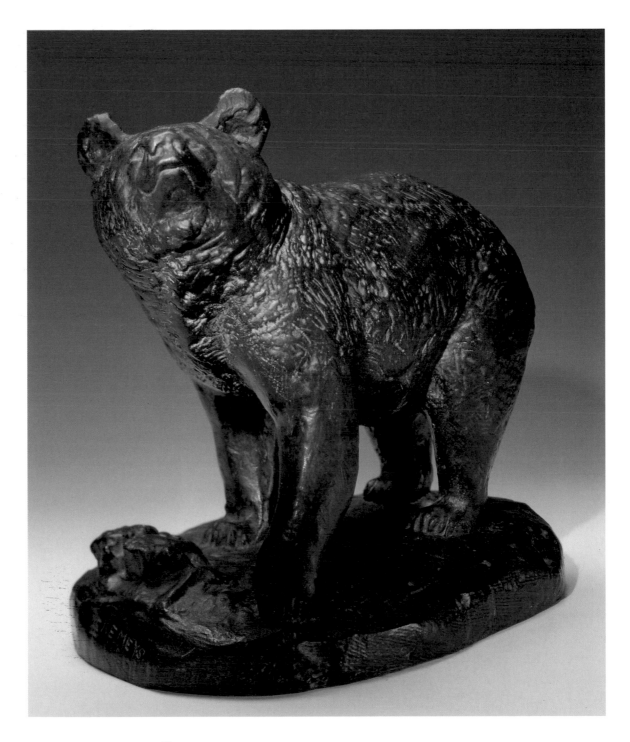

EDWARD KEMEYS

1843–1907

Buffalo and Wolves

1876, bronze
50.8 x 77 x 49.5 cm
Smithsonian
American Art
Museum, Gift of
J. Willis Johnson

Kemeys, a self-trained artist known for his animal sculptures, was fascinated by animal behavior exhibited in the wild. The turmoil and violence of this sculpture, in which a buffalo writhes in an effort to shake off four voracious wolves, shows his mastery of animal anatomy and engages the viewer in the deadly struggle of powerful opponents.

Although he moved to France and exhibited this work at the Paris Salon of 1878, Kemeys chose to return to the United States. The docile animals of Paris's Parc Zoologique just didn't inspire him. His work was fueled by the raw energy of the American West, where nature was untamed. Kemeys admitted to being terribly homesick while in Europe, "When I found myself on shipboard and pointed for America, I could have turned hand-springs all over the deck."

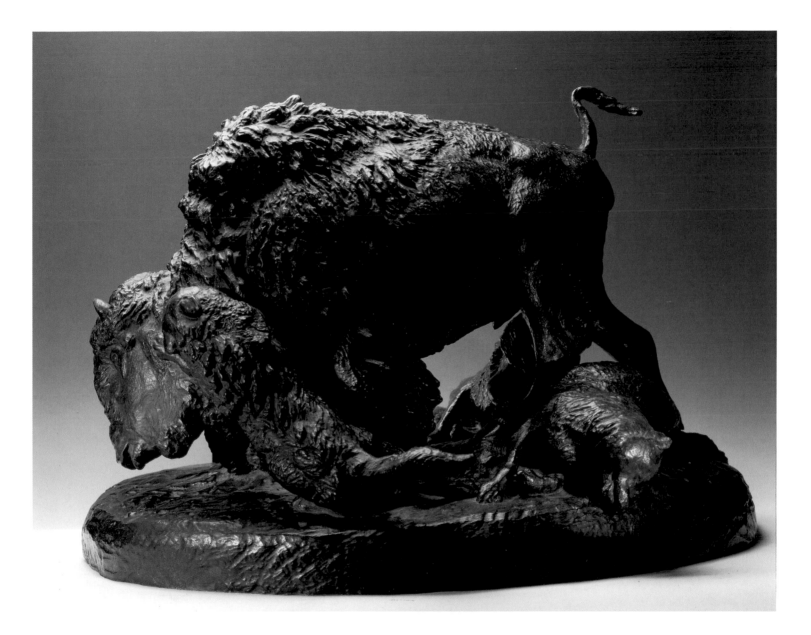

CHARLES BIRD KING

1785–1862

Young Omahaw, War Eagle, Little Missouri, and Pawnees

1821, oil

91.8 x 71.1 cm

Smithsonian

American Art

Museum, Gift of

Miss Helen Barlow

One of the most modern-looking of early Western images, King's dramatic group portrait continues to impress museum visitors. The way each figure's gaze is directed at a different part of the room, the dramatic blood-red face paint and colorful wampum, and, perhaps most wonderful, the colorful spiked hair of the men enhanced with deer hair draw us in.

The central figure wears a peace medal with President Monroe's profile. It is suspended, ironically, just above his war club. Surely this group, which was painted in the artist's studio in Washington, D.C., wanted to make an impression, for its delegation had come East to negotiate with U.S. legislators concerning its right to broker land deals. The artist managed to convey the noble dignity of the representatives, so crucial to its important mission.

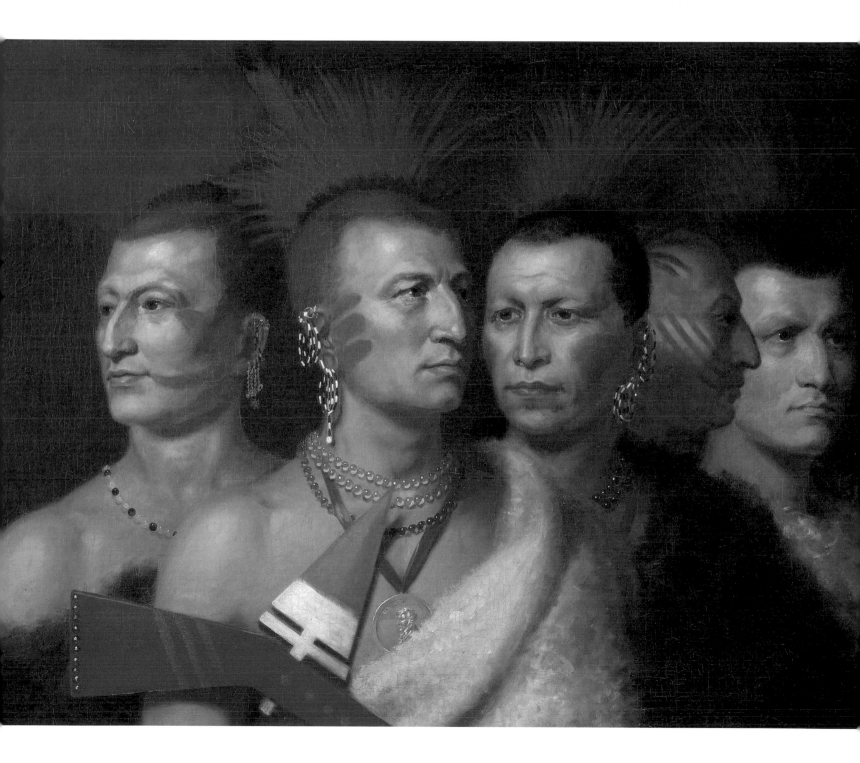

GENE KLOSS

1903–1996

Midwinter in the
Sangre de Cristos

about 1936, oil
50.8 x 76.8 cm
Smithsonian
American Art
Museum, Transfer
from the U.S.
Department of Labor

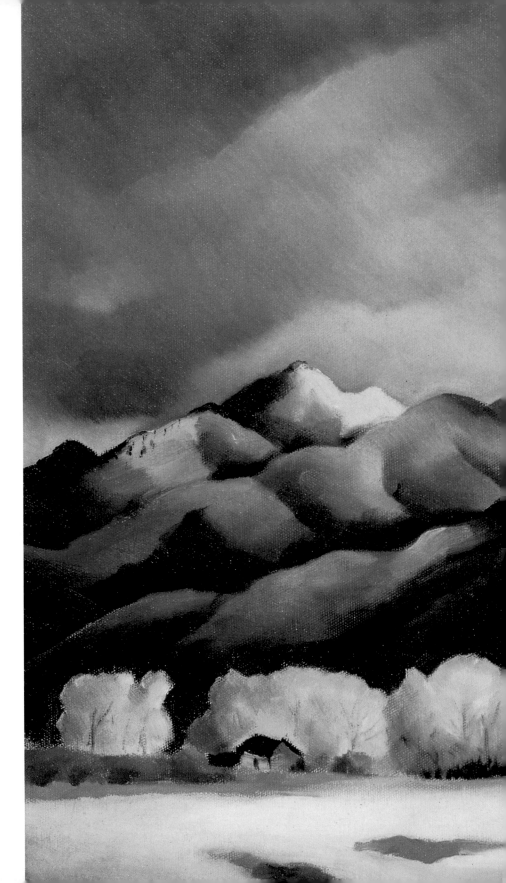

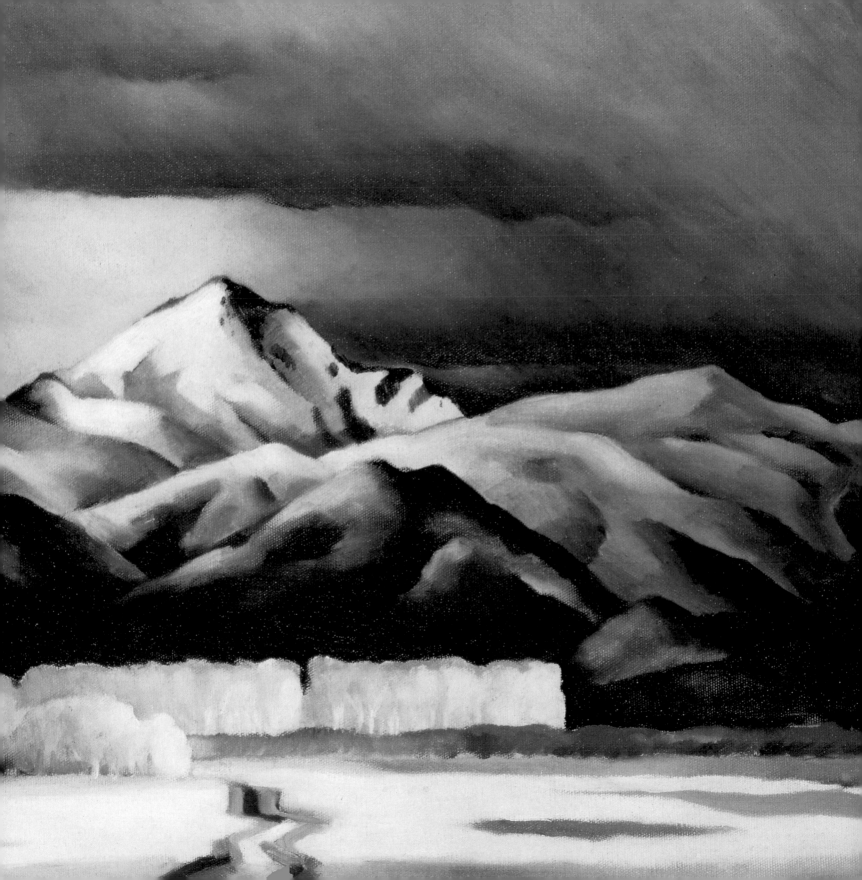

EMANUEL GOTTLIEB LEUTZE

1816–1868

Westward the Course of Empire Takes Its Way

1861, oil

84.5 x 110.1 cm

Smithsonian
American Art
Museum, Bequest of
Sara Carr Upton

This almost religious image of westward expansion is a study for a huge mural for the U.S. House of Representatives. The artist spared no effort on this important commission, and the canvas is filled with drama. The bottom portion of the painting has medallion portraits of Captain William Clark and Daniel Boone, two great American explorers. They flank a vista of the San Francisco Bay—the ultimate Western destination. Ornamental scrollwork filled with biblical and historical scenes of exploration and salvation borders the central image.

Near the center a wagon train ascends a steep precipice. A shrouded corpse is being laid under a cross, and an animal skeleton and half-buried wagon wheel are grim reminders of others who have passed this way. But the leaders of this bedraggled party maintain their optimism. One of the men has brought his family onto a rock to see the road ahead. Gesturing grandly westward, he hails the promise that lies beyond. Leutze convinces his audience that the West is a new Eden. With publicity like this, it is no wonder that so many Americans supported the U.S. government's policy of Manifest Destiny.

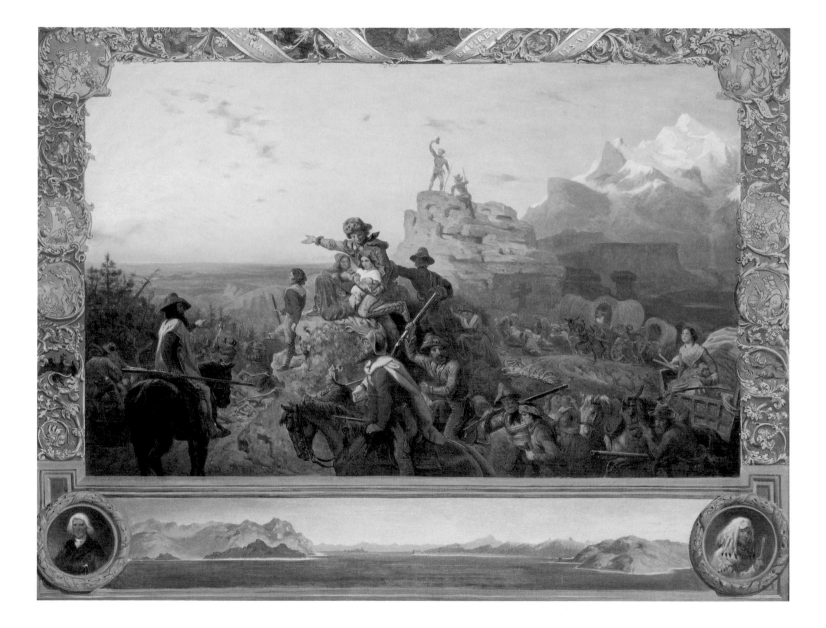

EDMONIA LEWIS

1843/45–AFTER 1911

Old Arrow Maker

modeled 1866,
carved 1872, marble
54.5 x 34.5 x 34 cm
Smithsonian
American Art
Museum, Gift of
Mr. and Mrs.
Norman B. Robbins

The life of Edmonia Lewis is as inspirational as her sculpture. Born to a Chippewa mother and an African American father, she was orphaned as a teenager but went on to attend Oberlin College and establish a studio in Rome.

Old Arrow Maker idealizes in smooth white marble the lives of native peoples. The father and daughter, depicted more like classical figures from antiquity than Native Americans, look up from their work. The man is making arrowheads, and the daughter is fashioning some type of mat. It is thought that Henry Wadsworth Longfellow's poem *Song of Hiawatha*, of 1855, inspired this work. In the poem Hiawatha offers a deer to Minnehaha as a token of marriage. Here, the deer lies at Minnehaha's feet, suggesting that father and daughter may be considering this marriage proposal while they work at their tasks.

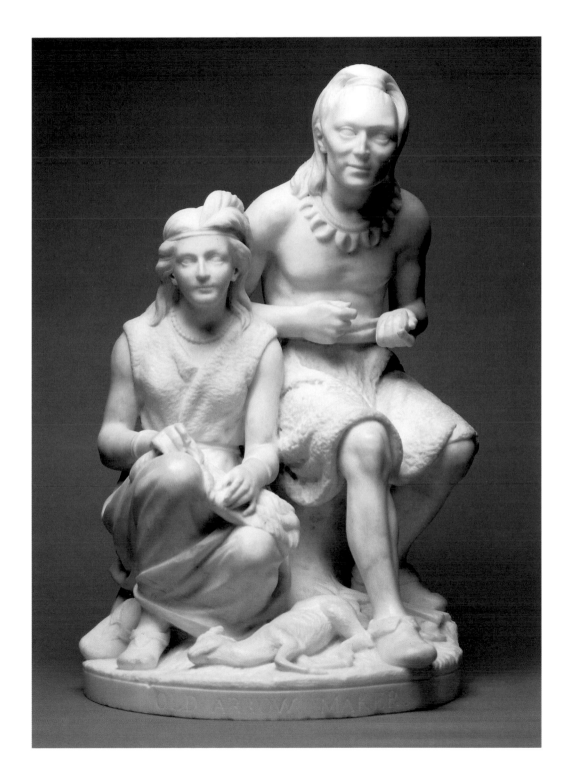

HERMON A. MacNEIL

1866–1947

A Primitive Chant to the Great Spirit

modeled by 1901
bronze
62.3 x 15.6 x 22.3 cm
Smithsonian
American Art
Museum

This bronze dancer is so full of movement, you wonder how the base can hold him stationary. He is a mass of angles and geometric surfaces that catch the light and animate his stance. The torso is twisted to the left so that weight is transferred to the muscular left leg, which rests on the metal base. Through all this contortion, the dancer's decorative feather remains perfectly—almost impossibly—upright.

Gift of Maurice Kawashima in honor of Dr. Richard Wunder

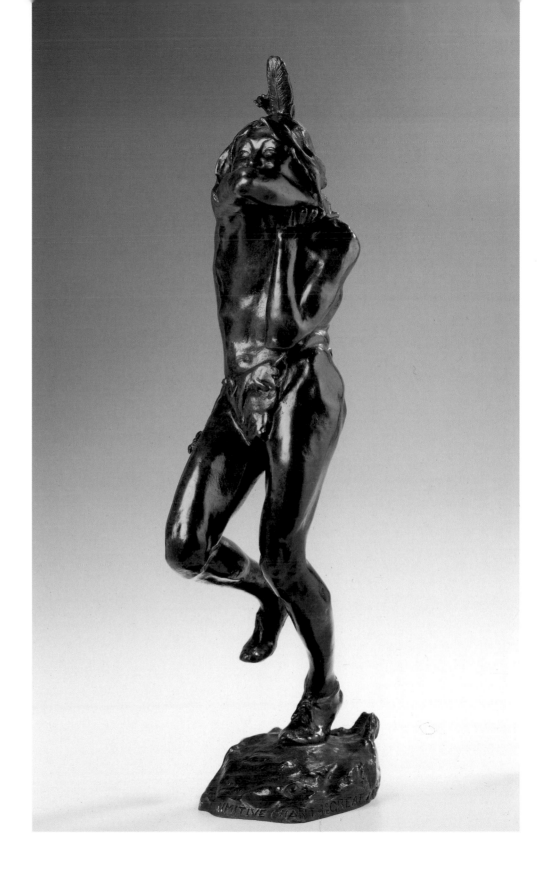

THOMAS MORAN

1837–1926

Cliffs of the Upper Colorado River, Wyoming Territory

1882, oil

40.5 x 61 cm

Smithsonian
American Art
Museum, Bequest of
Henry Ward Ranger
through the National
Academy of Design

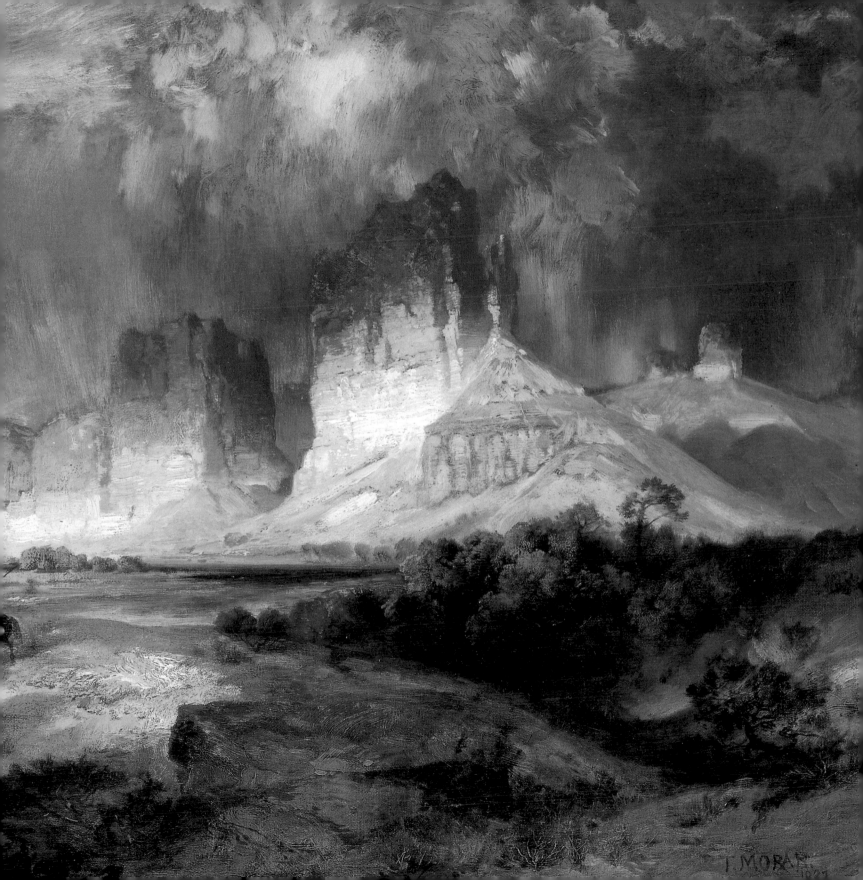

Mist in Kanab Canyon, Utah

1892, oil
112.7 x 97.5 cm
Smithsonian
American Art
Museum, Bequest of
Mrs. Bessie B. Croffut

Moran wrote, "I place no value on literal transcripts from Nature. My general scope is not realistic; all my tendencies are toward idealization. Of course, all art must come through Nature: I do not mean to deprecate Nature or naturalism; but I believe that a place, as a place, has no value in itself for the artist, only so far as it furnishes material from which to construct a picture."

Moran did much to create a powerful vision of the West for Americans who had never ventured there. Yet even as he painted scenes of wilderness populated only by Indians, these areas were rapidly filling with settlers. The Mormons lived in Kanab by the early 1870s, and a thriving community of settlers grew up near the Green River in Wyoming about the time Moran took up this subject.

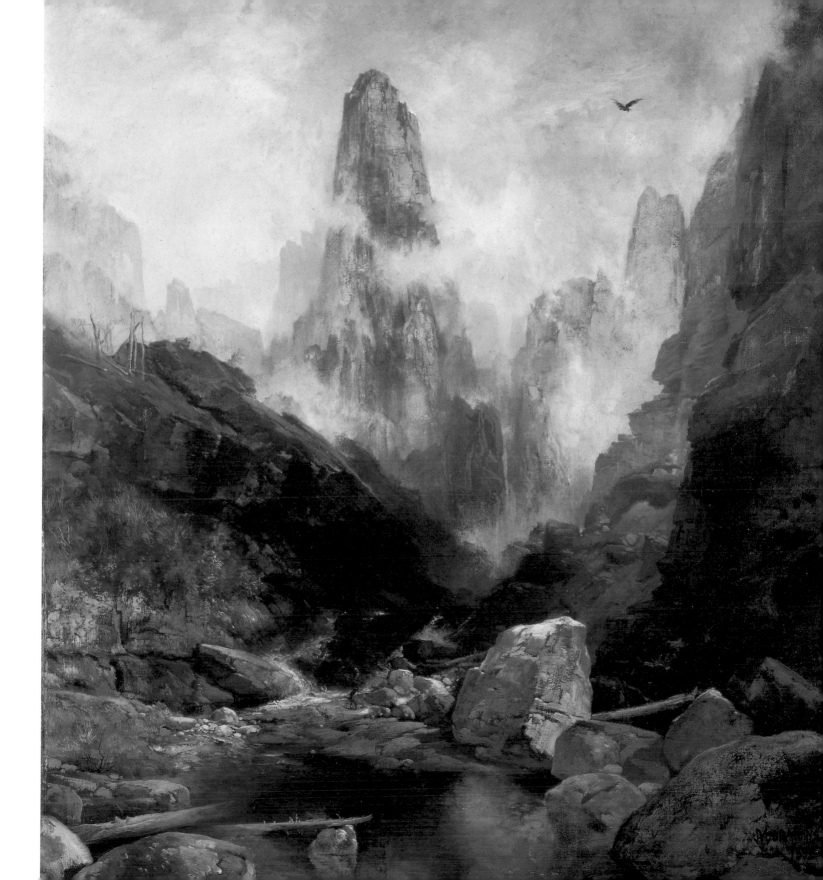

THOMAS MORAN

1837–1926

Rainbow over the Grand Canyon of the Yellowstone

1900, oil
76.5 x 94 cm
Smithsonian
American Art
Museum, Bequest of
Marion H. Conley

Moran could be a master of illusion. The world seems turned upside down as we plunge off a cliff into the Grand Canyon of the Yellowstone. The drama of light and dark—sun and shadow—creates agitation in the landscape. The turbulent sky and rushing water create an almost audible pandemonium. A vibrant rainbow emerges through the clouds, one of nature's most brilliant displays.

As an artist for the U.S. Geological Survey, Moran made many expeditions to the West. He saw Yellowstone for the first time in the summer of 1871 and returned regularly, painting the subject so often that he finally adopted a "Y" as part of his monogram signature. His ideal images were pivotal in convincing legislators in Washington that Yellowstone should be protected and preserved as the first national park.

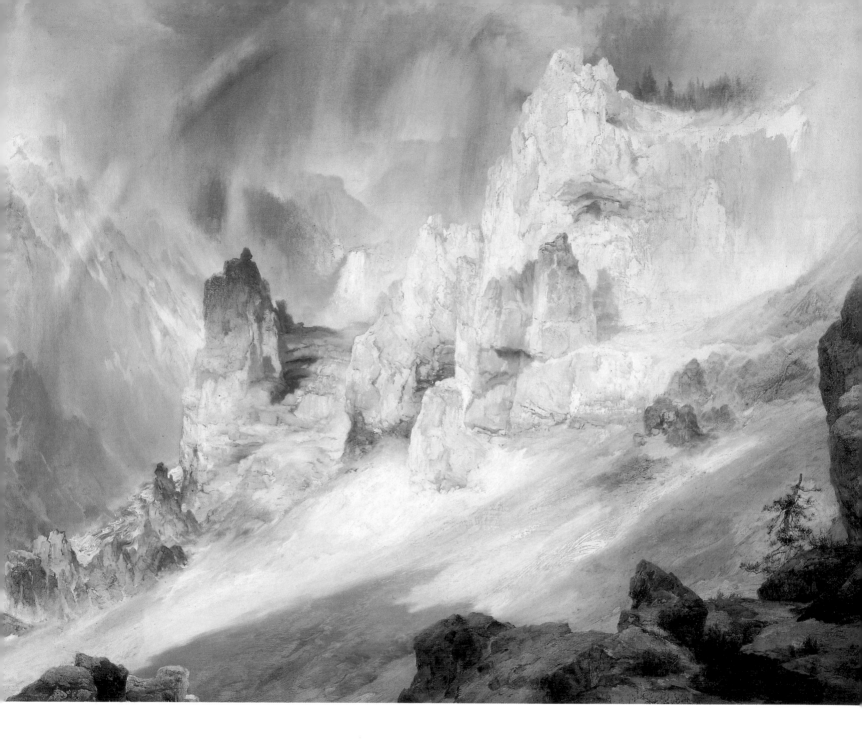

CHARLES CHRISTIAN NAHL **AUGUST WENDEROTH**

1818–1878 1819–1884

Miners in the Sierras

1851–52, oil
137.7 x 169.8 cm
Smithsonian
American Art
Museum, Gift of the
Fred Heilbron
Collection

Shortly after the discovery of gold along the American River near Sacramento in 1848, Charles Nahl left his native Germany and headed to California to seek his fortune. This scene, painted with his partner, August Wenderoth, who provided the background landscape, is the first-known oil painting of an early gold camp.

Four men are hard at work under a hot sun—one so wilted that he drinks from a bucket. They work in teams to build a placer mine, a device for diverting water so the streambed can be mined for nuggets. Their log cabin, a humble shelter with smoke coming from its chimney and the day's washing hung on a line, is in the middle ground.

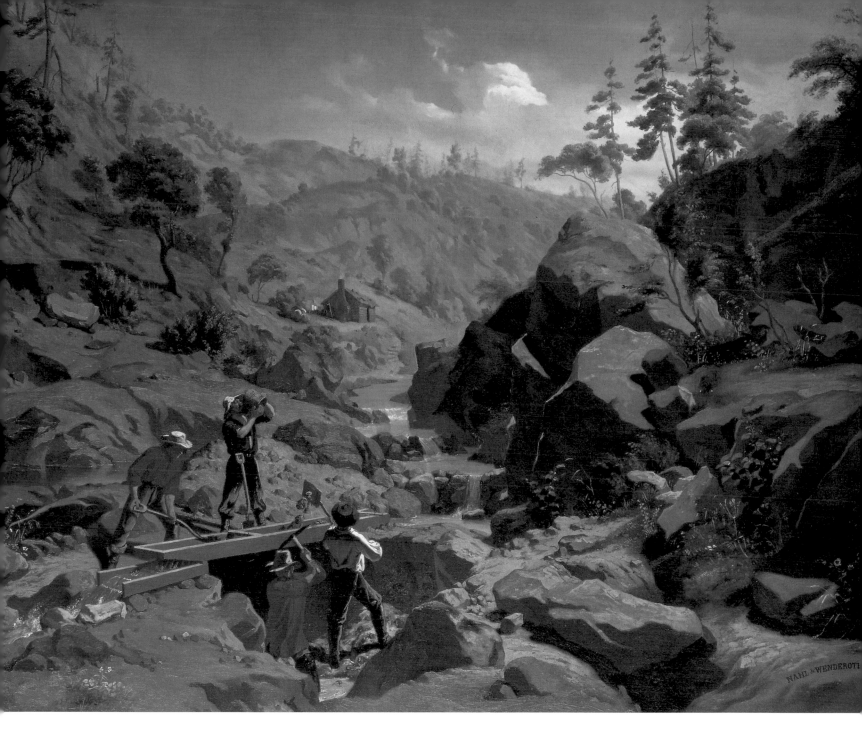

LOUIS POTTER

1873–1912

The Fire Dance

1907, bronze
76.2 x 29.8 x 29.8 cm
Smithsonian
American Art
Museum, Gift of
Mrs. George R. Percy

Fresh out of college, Louis Potter went to Paris with the intention of becoming a painter. He soon realized that sculpting, and not painting, was the form of expression most natural to him.

While in France, Potter developed an interest in ethnography and the depiction of other cultures. He traveled to North Africa where his portrayals of Bedouins came to the notice of the bey of Tunis, who decorated him with the Order of Renown and chose his work to represent Tunisian types at the Paris Exposition in 1900.

Once back in the United States, he turned his talents to the portrayal of Native Americans and to that end traveled among the Indians. *Fire Dance* is one of a series of sculptures about the fundamental elements of nature, a series that also included a *Dance of the Wind Gods*.

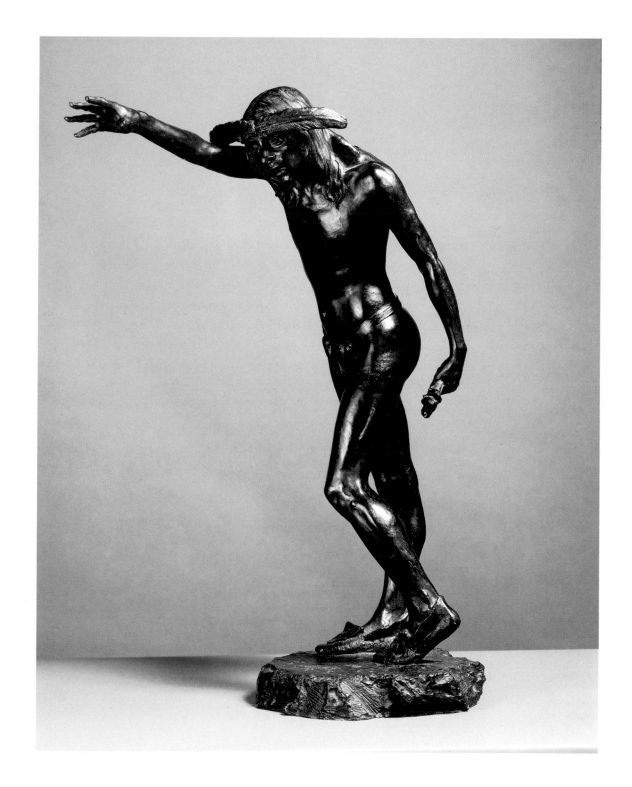

A. PHIMISTER PROCTOR

1862–1950

Pursued

modeled 1914,
remodeled 1928
bronze
43.3 x 61.3 x 14.3 cm
Smithsonian
American Art
Museum

Proctor executed a first version of this sculpture in 1914, using the Cheyenne Chief Little Wolf as his model. In 1928, he modeled this second version, changing what had been Little Wolf's spear into a tomahawk, slinging a quiver over his shoulder, and lowering the flap of his loincloth to keep it in line with the horse's tail. The effect of these changes is that the horse and rider seem to fly. The artist conveys movement, not only in the horse's straining limbs and open mouth, but also by setting him on a swirling base that looks like whipped-up grasses set in motion by his flying hooves. With tomahawk in hand, this warrior looks heroic, godly, and—despite being chased—ultimately unconquerable.

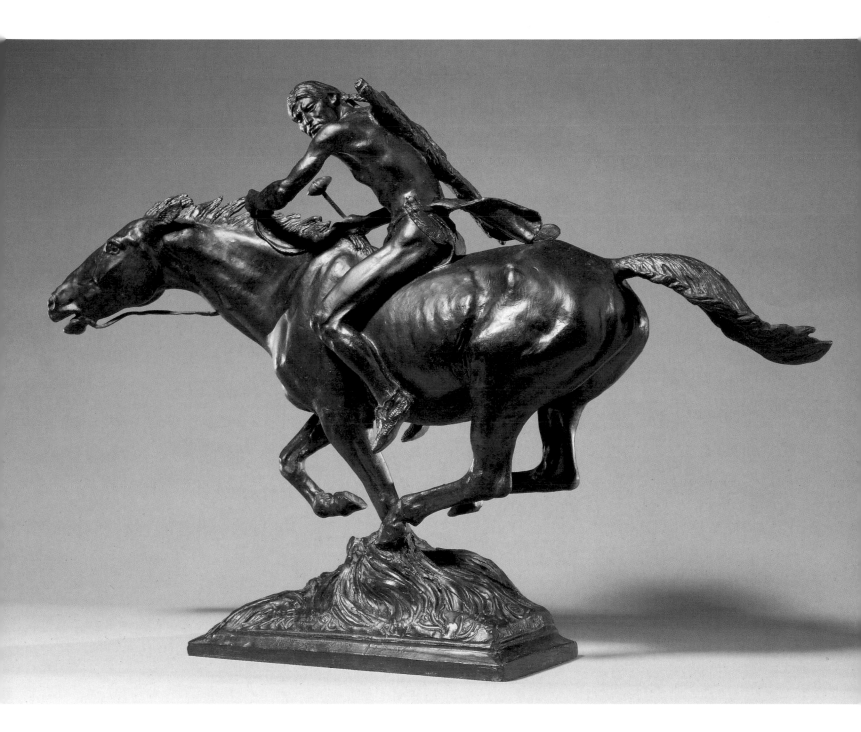

FREDERIC REMINGTON

1861–1909

Fired On

1907, oil
68.8 x 101.6 cm
Smithsonian
American Art
Museum, Gift of
William T. Evans

This almost cinematic image is one of the most dramatic of all Western paintings. As a band of horsemen approach a river's edge, bullets—depicted as slashes of paint—fly at them, splashing water, kicking up dust, and throwing all into turmoil. Through the greenish evening light, colored by an unseen moon, men slump and fall. A rider at left in the middle ground raises his arm, as if to signal surrender. But it's too late. The effect is surreal, and the disordered composition conveys the sinister side of the Wild West.

Remington catapulted to fame in the late nineteenth century after exhibiting works in prestigious national exhibitions. He roamed the Southwest and Mexico for subjects. This was an unlikely path for the son of a middle-class New York family, but Remington was intent on making a name for himself through his art.

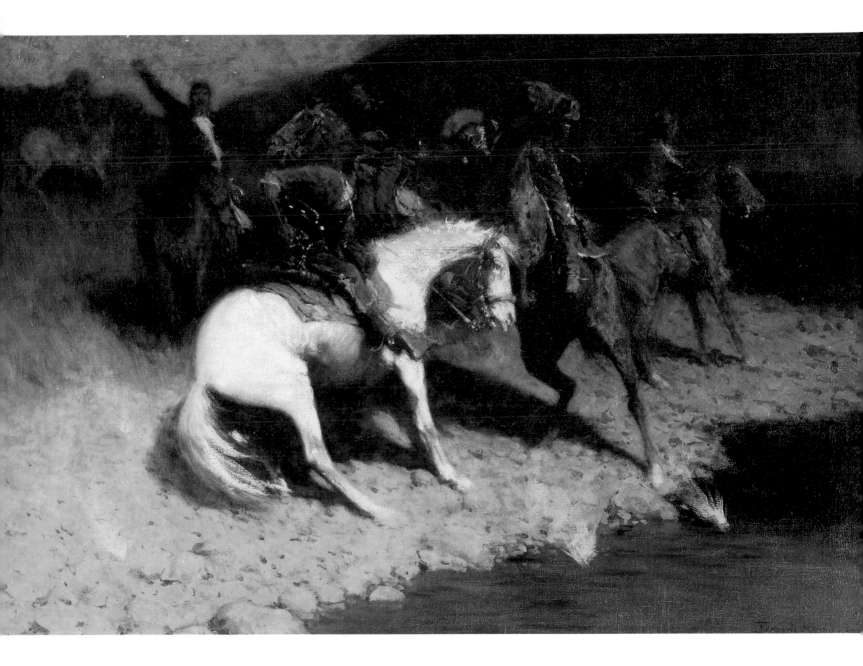

JOSEPH HENRY SHARP

1859–1953

Making Sweet Grass Medicine, Blackfoot Ceremony

about 1920, oil
76.2 x 91.7 cm
Smithsonian
American Art
Museum, Bequest of
Victor Justice Evans

Three young men with long braids, colorful headgear, fringed pants, and beaded shoes are seated in a circle in the warmth of a teepee. Their looks of concentration are indicators of the importance of the ceremony in which they are involved. Making medicine was a ritual action that preceded any new enterprise to ensure its success. While the ritual varied among the tribes, it often entailed the empowerment of objects that would act as magic fetishes and would be carried in "medicine bags." The ritual typically involved the cleansing of these objects with smoke.

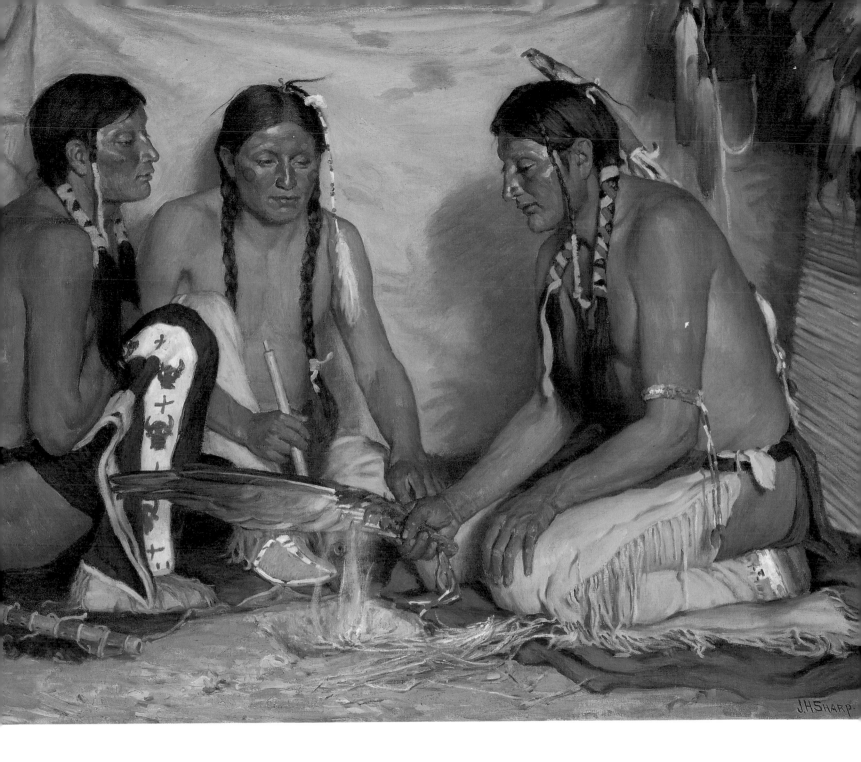

JOSEPH HENRY SHARP
1859–1953

Quinnah

1902, oil
45.7 x 31 cm
Smithsonian
American Art
Museum, Bequest of
Victor Justice Evans

Quinnah, a Crow warrior, sat for Sharp in 1902. Later, the artist wrote a letter about him: "Quinnah, Flathead (1902). A very strong type of young warrior, horse raider from the Crows and other tribes. Very reticent about his exploits. Became loyal to the Gov'mt and a model and progressive Indian, at that early date."

By praising both his bravery in war and loyalty to the U.S. government, Sharp expresses a fundamental conflict of his generation's attitude toward Indians.

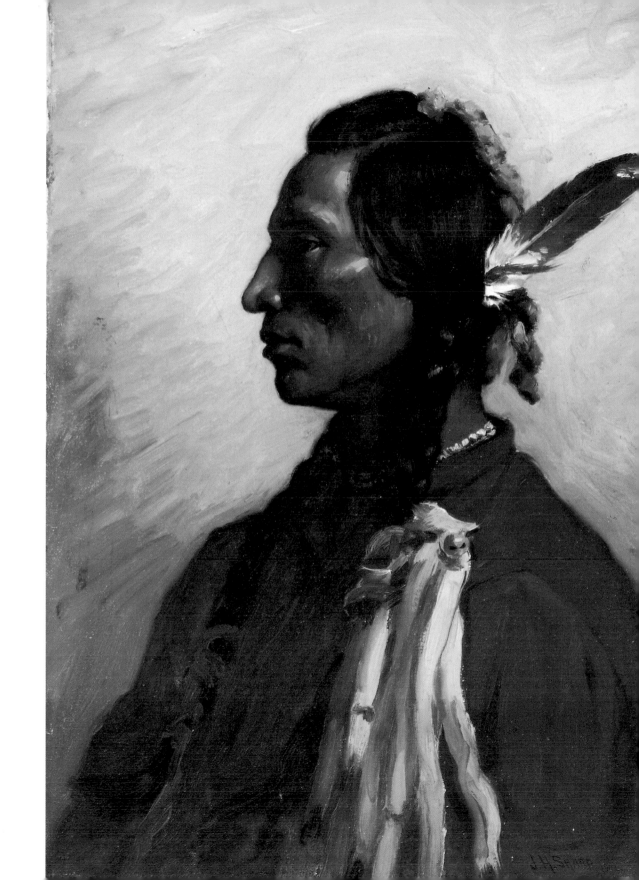

JOSEPH HENRY SHARP

1859–1953

Sunset Dance–Ceremony to the Evening Sun

1924, oil
63.8 x 76.2 cm
Smithsonian
American Art
Museum, Gift of
Arvin Gottlieb

In 1920, Sharp declared, "In the past years I have seen so many things . . . that probably no other living artist ever saw, such as the Tobacco Dance, Graves, Burials, etc., that if I don't ever paint them, no one ever will." Here he uses extraordinary light and vibrant colors to convey a sense of timeless ritual. Brightly clothed villagers in serapes, hats, hair ornaments, and tunics gaze into the pink light. The crowd extends all the way back to the center of town, where the simple adobe dwellings form a pyramid beneath lush hills.

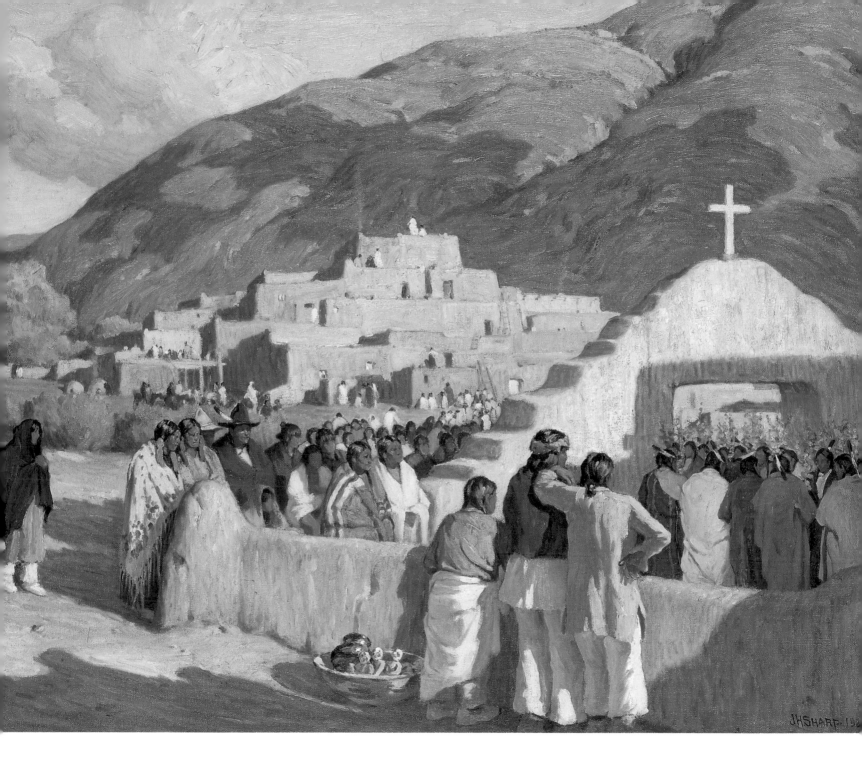

JOSEPH HENRY SHARP

1859–1953

The Voice of the Great Spirit

1906, oil
101.6 x 76.3 cm
Smithsonian
American Art
Museum, Bequest of
Victor Justice Evans

On a rocky plateau a burial scaffold has been constructed. Four cut saplings hold the draped corpse under cloudy skies. Horse heads and tails hang from the supports. These steeds, although disembodied, appear prepared to transport the departed to a final resting place. A feathered staff leans against the structure. A lone bird looks down upon a single mourner. A supernatural element seems to be whipping her like the wind.

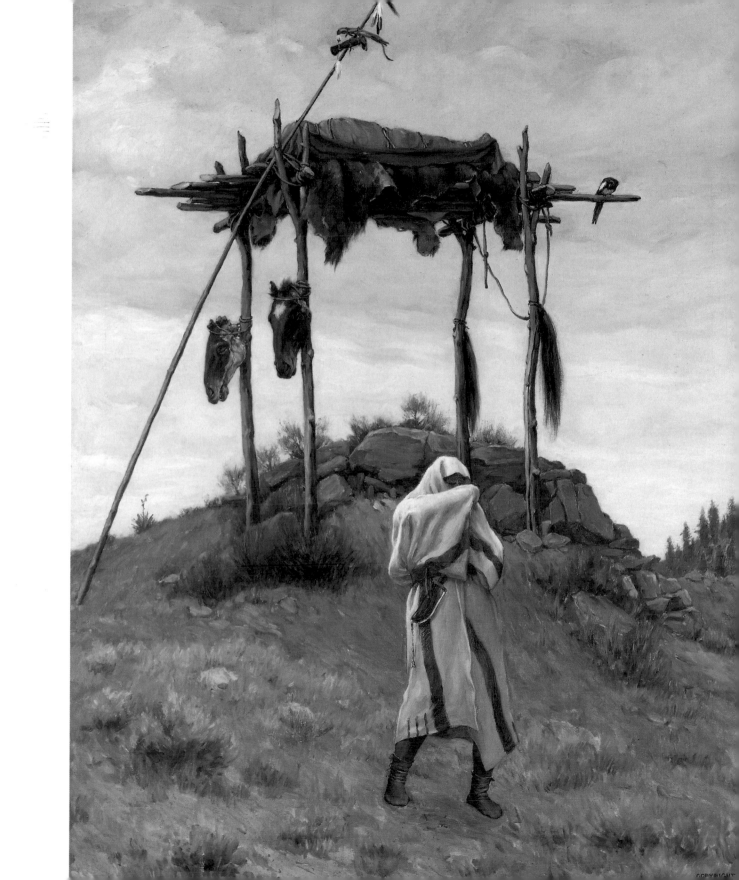

JOHN MIX STANLEY

1814–1872

Black Knife, an Apache Warrior

1846, oil
107.8 x 132.1 cm
Smithsonian
American Art
Museum, Gift of
the Misses Henry

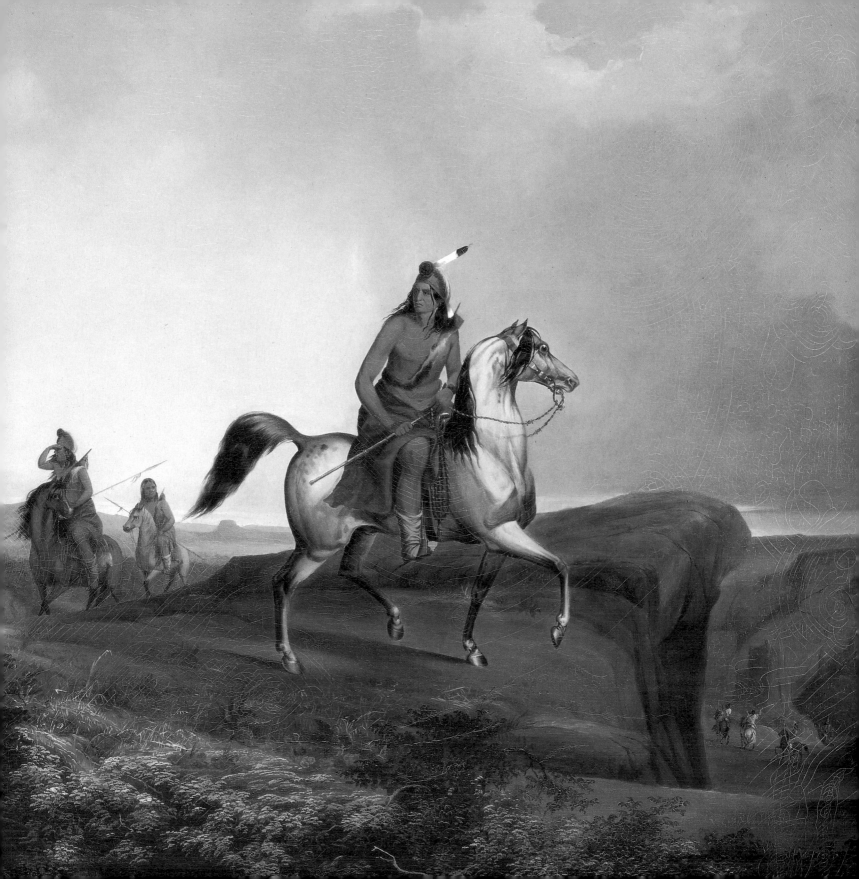

JOHN MIX STANLEY

1814–1872

Osage Scalp Dance

1845, oil

103.5 x 153.6 cm

Smithsonian

American Art

Museum, Gift of

the Misses Henry

This painting is one of only a few of John Mix Stanley's works to survive a disastrous fire at the Smithsonian in 1865. Approximately 150 of his paintings were lost.

The fiery red-painted Osage warriors dance around a white woman and her child. They form a frightening semicircle around the pair. And she—powerless before all those armed men, their strength so great it seems to ignite a sky suffused with a smoky purple color—clings to her child.

Is the curly headed youth the next victim of the angry Osage wielding a war club overhead? Another warrior—with a presidential peace medal around his neck—holds out his spear to block the club. These two Indians—one threatening and one helpful—symbolize the complexity of relations between Indians and the many settlers moving into their territories in the 1840s.

Osage Scalp Dance is one of approximately eighty works that Stanley created from subjects he gathered when traveling through little-known frontier areas between 1842 and 1853. Stanley attracted many paying visitors to his Indian Gallery, for his images both confirmed and defied their notions about Native American culture.

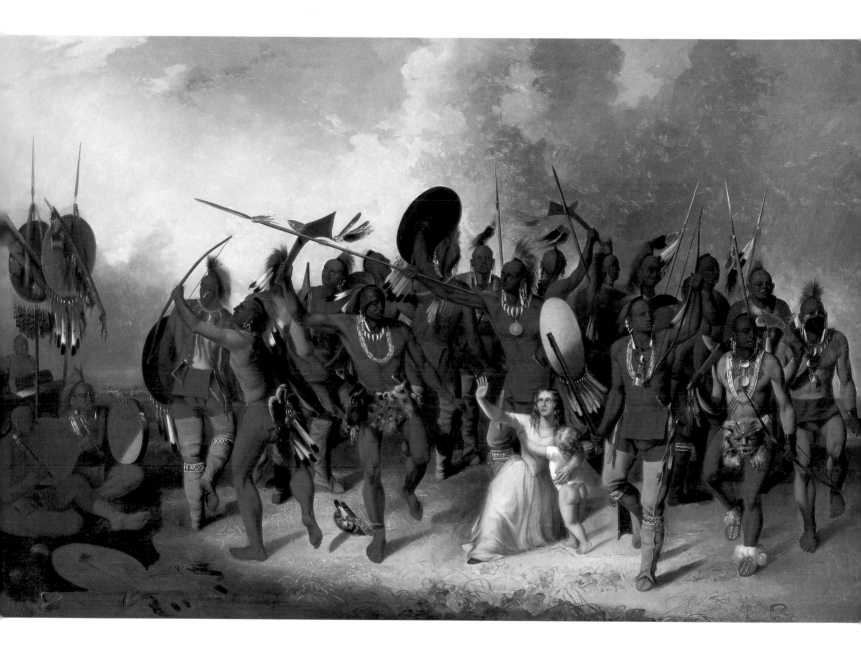

JOHN MIX STANLEY

1814–1872

Buffalo Hunt on the Southwestern Prairies

1845, oil
154.3 x 102.8 cm
Smithsonian
American Art
Museum, Gift of
the Misses Henry

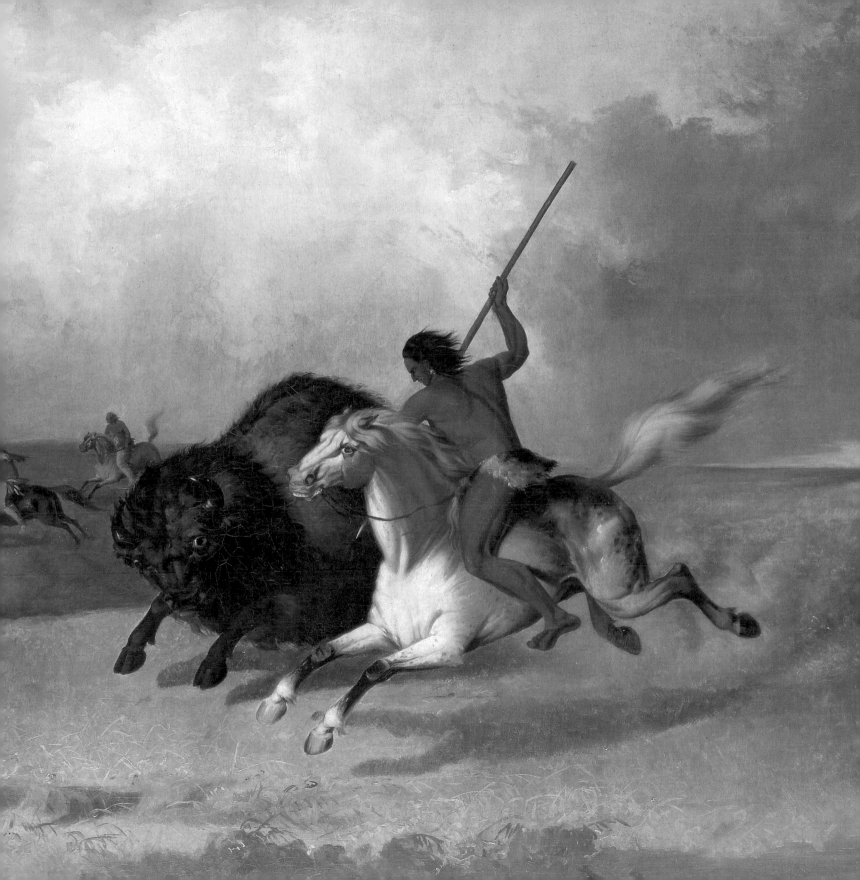

LEON TROUSSET

ACTIVE 1870S–1880S

Old Mesilla Plaza

about 1885–86, oil
75.1 x 123.2 cm
Smithsonian
American Art
Museum

This early painting—about 1885—is important because it documents an Hispanic settlement in the Southwest that was known to few outside that territory. The layout and character of the town is reminiscent of the first Spanish settlements in the New World, and the small figures in the plaza wear the typical clothing of northern Mexico. The priest to the left of the church façade wears a long black cassock and black, brimmed hat. The man on the burro is covered by a Saltillo serape, and the women at the church are seen in mantas and flowing dresses. The covered wagon in the main plaza implies that La Mesilla was on a trade route. And indeed it was a stop on the El Camino Real—the Royal Highway—the road that connected Santa Fe with major cities in Mexico.

Leon Trousset, originally from France, was painting on the West Coast as early as the 1870s. He may have been making sketches of the Western territories on commission by the U.S. government. His accurate depiction of La Mesilla gives us a sense of a Southwest that was virtually unknown to all but a few travelers, and reminds us that our continent was still largely foreign territory.

Transfer from the Bureau of American Ethnology, Smithsonian Institution

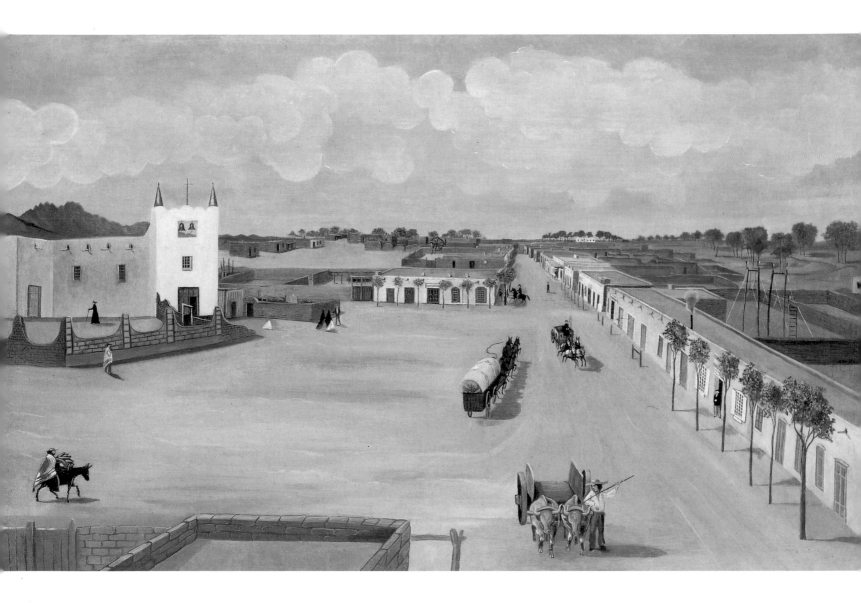

WALTER UFER

1876–1936

Callers

about 1926, oil
128.4 x 128.4 cm
Smithsonian
American Art
Museum, Gift of
Mr. and Mrs.
R. Crosby Kemper Jr.

Among the members of the Taos Society of Artists, Walter Ufer is credited with portraying the Pueblo Indians in the most realistic and objective manner. Ufer rejected an idealized view of native culture: "I paint the Indian as he is. In the garden digging—in the field working—riding amongst the sage—meeting his woman in the desert—angling for trout—in meditation. . . . [The Indian] is not a fantastic figure. He resents being regarded as a curiosity."

Ufer has caught a lovely moment. We have no idea why the callers have arrived or any clue about the significance of their visit, but we are encouraged by the gentle reluctance of the gatekeeper and feel that the men will find welcome shelter from their journey. The shy girl—perhaps the object of their visit—seems almost to smile as she allows them to enter.

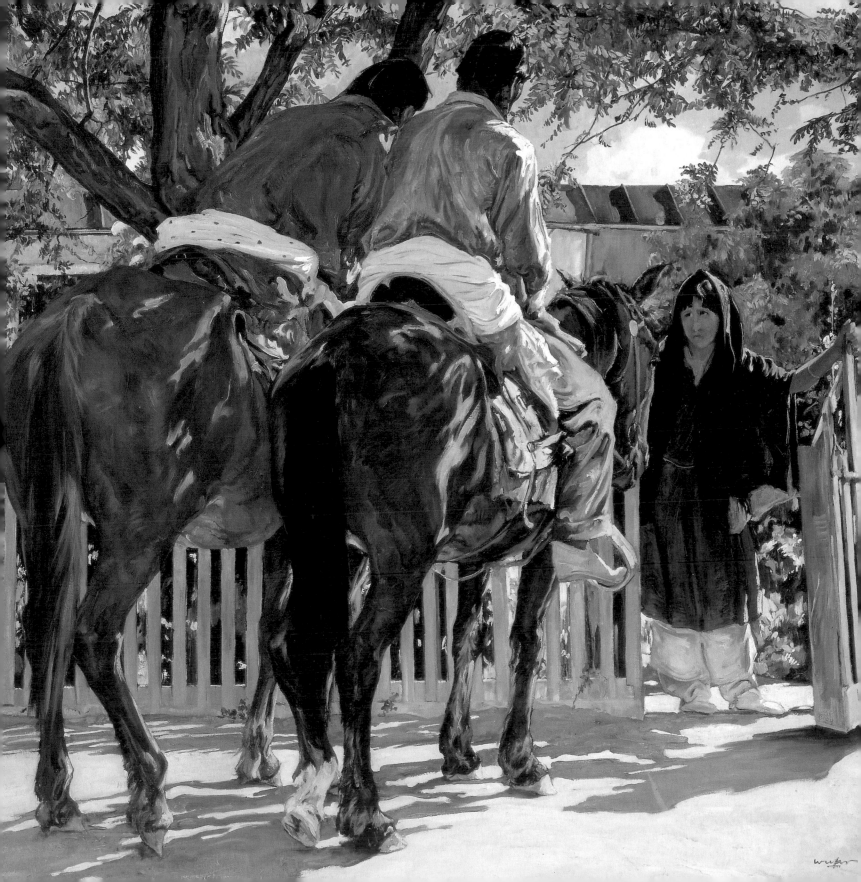

OLIN LEVI WARNER

1844–1896

"Joseph," Hin-Mah-Toó-Yah-Lat-Kekht, Chief of the Nez Perce Indians

1889, bronze
44.8 cm diam.
Smithsonian
American Art
Museum

Warner, a sculptor trained in the classical style in Paris, met Chief Joseph on a trip west in 1889. Urged by a friend who feared the changes in Indian cultures, he began to record the likenesses of some well-known chiefs. The success of this bronze relief led him to execute other fine portraits of Native American subjects. His bronzes are both an enduring record of great chiefs of that period as well as brilliantly crafted works that reveal superb modeling and form.

Chief Joseph of the Nez Perce tribe, known for his great moral conduct and strategic skill in warfare, was much admired and respected even by his opponents. Here he is immortalized in a medium and format reminiscent of Renaissance medals, with a bold profile and inscription.

A Gift of Alison Warner Waterman in memory of her mother, Frances D. Warner

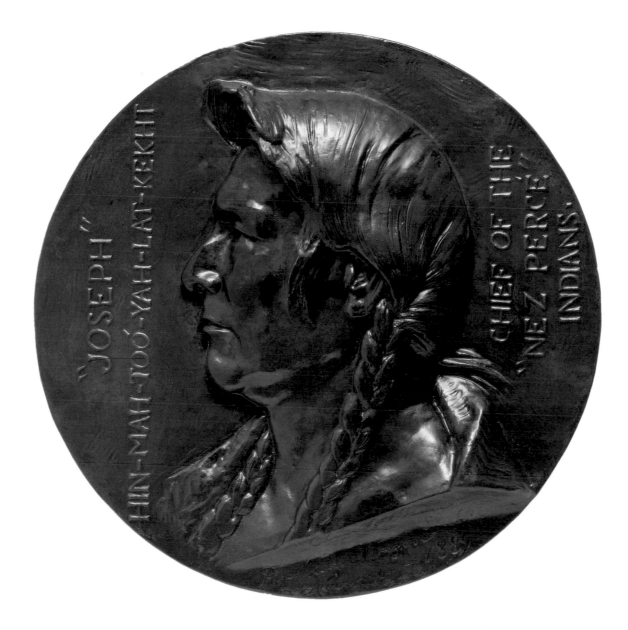

Index of Titles

The Smithsonian American Art Museum is dedicated to the preservation, exhibition, and study of the visual arts in America. The museum, whose publications program also includes the scholarly journal *American Art*, has extensive research resources: the databases of the Inventories of American Painting and Sculpture, several image archives, and a variety of fellowships for scholars. The Renwick Gallery, one of the nation's premier craft museums, is part of the Smithsonian American Art Museum. For more information or catalogue of publications, write: Office of Print and Electronic Publications, Smithsonian American Art Museum, Washington, D.C. 20560-0230.

The museum is also on the Internet at **AmericanArt.si.edu.**